CUDAHY
SNAPSHOTS OF COMMERCE

Images of America

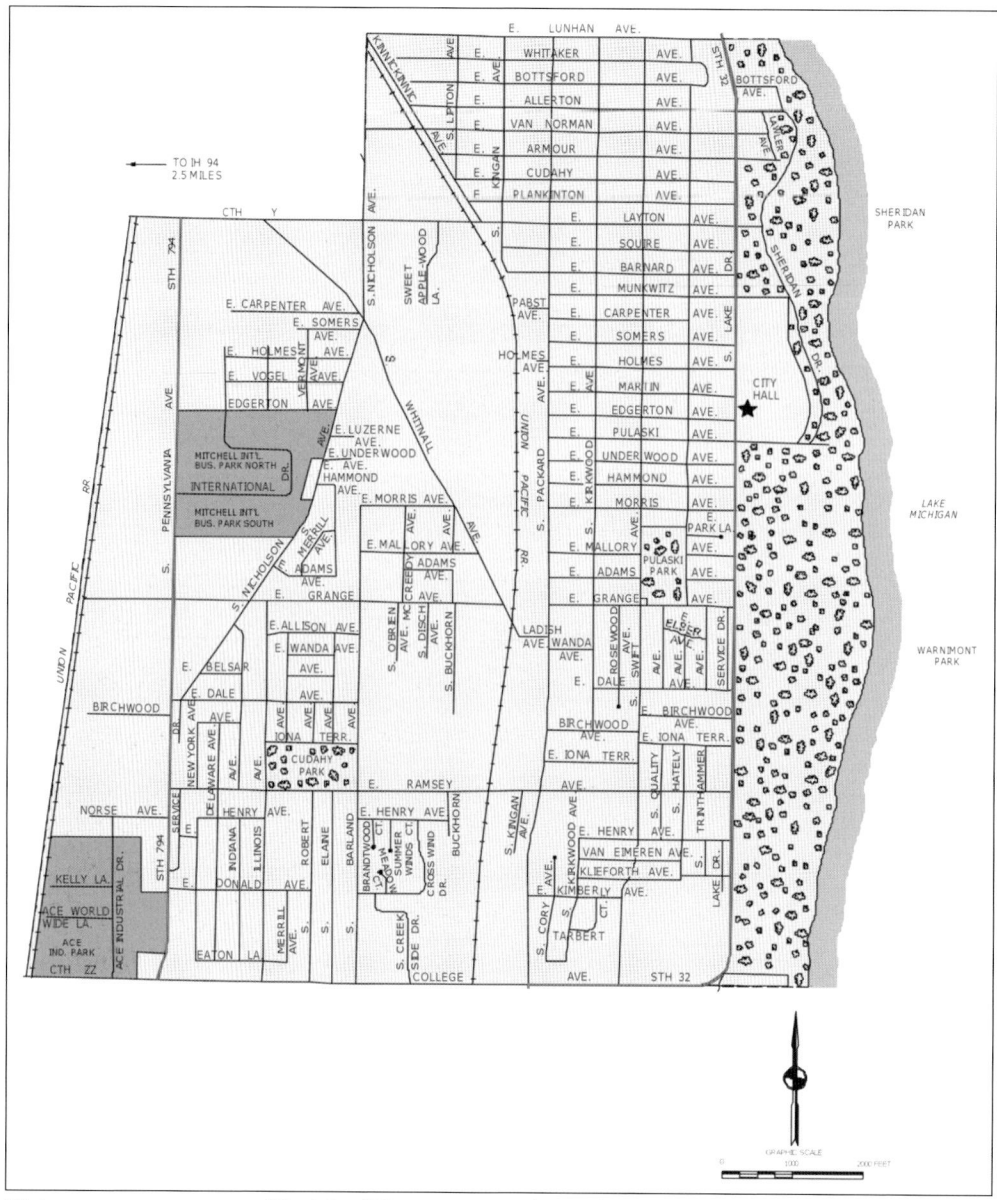

This contemporary map of Cudahy, Wisconsin, was drawn for business and economic development purposes in 2005. (Courtesy of Southeastern Wisconsin Regional Planning Commission.)

ON THE COVER: Several employees of the Cudahy Brothers Company meatpacking plant are shown preparing orders for shipment in the early 1920s. The racks behind the employees hold the cured meat, which was wrapped, weighed, and packaged into wooden boxes for transport. The company had retail outlets throughout the United States as well as Europe, and goods were delivered by truck, rail, and ship. (Courtesy of the Katherine Quentin Eaton Local History Collection of the Cudahy Family Library.)

IMAGES of America
CUDAHY
SNAPSHOTS OF COMMERCE

Rebecca Roepke and Michelle Gibbs

Copyright © 2016 by Rebecca Roepke and Michelle Gibbs
ISBN 978-1-4671-1493-6

Published by Arcadia Publishing
Charleston, South Carolina

Printed in the United States of America

Library of Congress Control Number: 2015941414

For all general information, please contact Arcadia Publishing:
Telephone 843-853-2070
Fax 843-853-0044
E-mail sales@arcadiapublishing.com
For customer service and orders:
Toll-Free 1-888-313-2665

Visit us on the Internet at www.arcadiapublishing.com

*Dedicated to Dr. Janet and Judge Richard D. Cudahy,
steadfast friends of the Cudahy Family Library.*

Contents

Acknowledgments		6
Introduction		7
1.	A Good Move for Cudahy Brothers	9
2.	Patrick Fulfills His Business Vision	31
3.	A New City Booms with Business	51
4.	Business Challenges in Depression and War	75
5.	Businesses Prosper in Postwar Economy	93
6.	Time for Redevelopment and Revitalization	111

Acknowledgments

This project would not have been possible without assistance from many people in our community. Thank you to all of the businesses and individuals who generously donated time and historical materials for this project. Thank you also to the businesses that allowed us to take photographs and also provided information for this book.

Special thanks to Dennis Adamczak, Judy Balistrieri, Carey and Jeanne Catania, Jennifer and Cortney Clark, Janet and Dick Cudahy, City of Cudahy Assessor's Office, Cheri and Tony Day, Damian and Kathy Dominski, Hub Dretzka, Heidi Eichner, Carol Eisenberg, Mary Gaidosh, John Gargulak, Judith Geiger, Mike Helgeson, Joan Houlehen, Bill Jaehnert, Dan Kapella, Darinka Kohl, Jerry Kotarak, Landmark Credit Union, B.J. Law, Mark Leistickow, Sue Malovec, the Milwaukee County Historical Society, Joanne Nigorski, John O'Malley, Jim Petersen, the Michael Pinter Family, Pioneer Commercial Cleaning, Carol Ponchik, Marc Ponto, Bob Puetz, Kathy Rasmussen, Duane and Roxanne Rickaby, Jane Schilz, Dennis Skwor, Jeff Steren, Mary Alice Tamsen, Gail Trapp, Sharon Vaccaro, Regina Valuch, the Wisconsin Slovak Historical Society, the Wisconsin State Historical Society, and Geraldine Zeniecki.

Thank you to Bob Pecher of B & L Photo Lab, who served as the photographer for this project. Unless otherwise noted, all images appear courtesy of the Katherine Quentin Eaton Local History Collection of the Cudahy Family Library.

Introduction

Perched on the bluffs overlooking Lake Michigan, Cudahy, Wisconsin, grew from a small settlement known as Buckhorn to today's modern city thanks to the efforts of Patrick Cudahy. Patrick and his brother John established the Cudahy Brothers Company meatpacking plant in Milwaukee in 1888 but decided to relocate south of the city. After purchasing about 800 acres from area farmers, the brothers erected a state-of-the-art plant, and a city took root.

Originally, the brothers had hoped to attract other Milwaukee meatpackers to the area, envisioning a packing center with large public stockyards. When none of the other packing plants could be convinced to move, Patrick reimagined what this new community could be. Instead of a city of stockyards and slaughterhouses, he was determined to create an industrial community with quality housing and services, making the city an attractive place to live. Patrick was instrumental in the growth of the city by encouraging others to establish businesses there, working to have a new railroad depot constructed, and arranging for basic infrastructure. He donated lands for schools and churches, laid out streets, planted trees, and established parks—quite literally shaping the new city of Cudahy.

All of the hard work paid off as the city flourished. Major industries like Ladish Drop Forge and Federal Rubber established operations, and smaller businesses like retail stores, theaters, taverns, and hotels followed. As the city grew, so too did the packing plant, adding on as sales increased and expanding into overseas markets. About half of Cudahy's population were first- or second-generation immigrants, many of whom were saving to bring family members over from their home country.

After the stock market crashed in 1929, the ensuing economic depression did not spare Cudahy. Businesses both large and small struggled to weather the downturn. Some businesses, like Ladish and Cudahy Brothers, were able to rely on their reserves and diversify, eventually emerging from the era leaner but intact. Other companies like Federal Rubber, a major Cudahy employer, went out of business. The loss of jobs and income rippled through the community, as the displaced workers had no income to spend and no prospect of improvement.

Cudahy's economy slowly rebounded, mirroring the national recovery. As the country entered into World War II, federal contracts were awarded to local companies for wartime production. Ladish was a major supplier of parts for a variety of military equipment, operating three shifts six or seven days a week. Likewise, Cudahy Brothers supplied troops with over 172 million pounds of meat and other perishables. Smaller businesses also played a role in the war effort, selling war bonds, making do with less, and rationing. By the end of the war, Cudahy's businesses were expanding, and the city had emerged as a community with plentiful jobs and family-friendly living.

In the early 1950s, the city of Cudahy more than doubled in size as lands were annexed from the surrounding town of Lake. This increase in both size and population required additional infrastructure developments but expanded the city's pool of potential consumers and employees. The vibrant downtown business district was already home to a variety of retail outlets, restaurants

and taverns, service stations, and banks when Packard Plaza, the first shopping mall serving Milwaukee's south side, opened in 1956. The plaza was home to a variety of high-end shopping destinations and was the site of Cudahy's first McDonald's.

Business was also booming in the city's manufacturing plants. Contracts for the aerospace industry were a boon for several local companies, including Ladish, Lucas Milhaupt, and United Welding. Cudahy Brothers continued to expand its operations, introducing its famous "sweet apple-wood smoke" flavoring in 1954. In 1957, the company was renamed Patrick Cudahy Inc. in honor of its founder. Smaller businesses like Dretzka's, Dutchland Dairy, Valuch Plumbing, and Nelson's Ice Cream sponsored community events or offered a welcome place for the community to gather. The 1950s and 1960s were a great time to live in Cudahy, with good paying jobs, affordable housing, and plentiful services available throughout the city.

By the 1970s, business growth had begun to slow as high inflation, rising unemployment, and declining industrial contracts combined to weaken the overall business climate. Lengthy strikes at Ladish and Patrick Cudahy Inc. also reduced consumer spending power, and the eventual loss of about 3,700 jobs had a substantial effect on the local economy. Several other major employers either closed or relocated, and many stores, restaurants, and taverns changed hands or went out of business altogether. Empty buildings and storefronts lined the industrial corridors and downtown business district.

Hoping to regain founder Patrick Cudahy's vision of a thriving, diverse community, the City of Cudahy formed an economic development plan and began providing incentives for businesses to relocate. Cudahy's ready access to a variety of transportation modes—including freeways, railways, and the airport—as well as a skilled workforce, have long made it an appealing option for industrial development. After Vilter Manufacturing moved to an unused portion of Ladish in the mid-1990s, things began to look up. In recent years, NPS Corporation moved into the former Bostrom manufacturing plant on Layton Avenue, and Angelic Bakehouse erected a new commercial bakery on the former site of the Federal Rubber lands. Smaller community-minded businesses have also moved into Cudahy in recent years, including Jen's Sweet Treats, the Gift Shoppe, Papa Luigi's, and South Shore Cyclery, to name just a few.

Today, Patrick Cudahy might not recognize the city that he helped to create, but some things would be very familiar to him. Dretzka's Department Store remains on Packard Avenue, where it has been doing business for well over 100 years. Ladish is now known as Allegheny Technologies Inc. (ATI), but residents can still feel the vibrations when the giant counterblow hammer is in operation. The Cudahy Depot that Patrick was instrumental in having built has been restored, and today serves as a historical museum. Most importantly, a spirit of community still abounds in the city as residents gather for parades, festivals, and other celebrations. Both the city of Cudahy and its businesses have seen many changes through the years, but the future certainly remains bright.

One
A Good Move for Cudahy Brothers

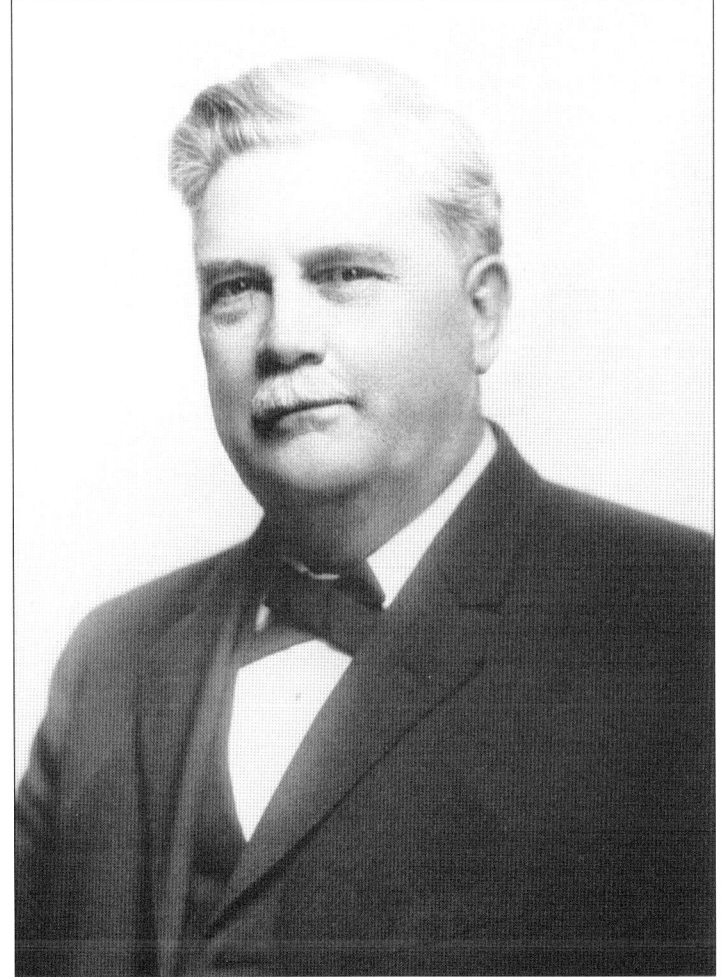

Patrick Cudahy was born in Ireland on St. Patrick's Day in 1849. He began working in the meatpacking business at the age of 13. In 1888, he started his business legacy, the Cudahy Brothers Company. Patrick provided affordable housing for workers, laid out the streets of Cudahy, and fought to ensure public transportation to his factory. He donated generously to local churches, schools, and charitable organizations. Patrick Cudahy died July 25, 1919.

Patrick's older brother, John Cudahy, was a silent partner in the Cudahy Brothers Company, providing financing for the new company. Like Patrick, John entered the meatpacking trade at a young age. Later, he became a speculator, gaining and losing fortunes while playing an influential role on the Chicago Board of Trade. On the day of John's funeral in 1915, the plant was closed for two hours out of respect.

Patrick Cudahy placed great importance on his family, which was reflected in the company stock certificates. Patrick and his wife, Anna, are at center, and the children are, clockwise from the top, John, Irene, Mary, Josephine, Michael, Katherine, Elizabeth, and Helen. The only child not pictured is Patrick and Anna's youngest son, William, who died at the age of two.

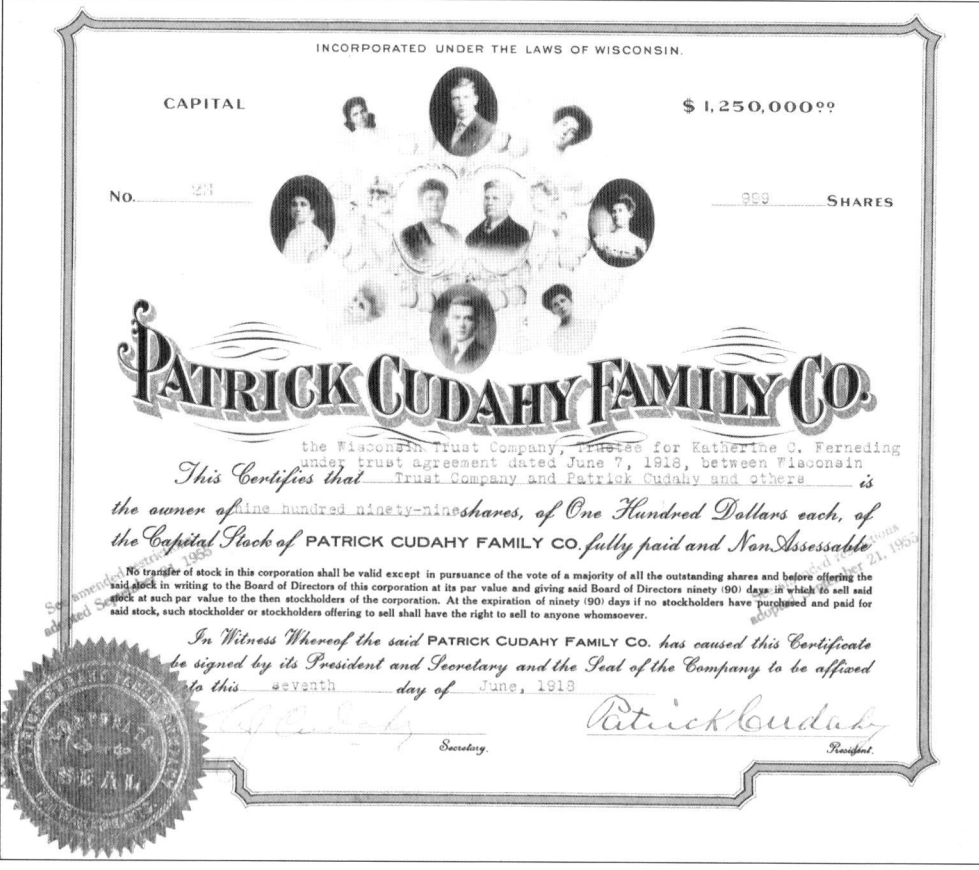

Patrick's oldest son, Michael, started working for the company in 1908. After learning the trade, he became president in 1919 after his father died. Michael led the company until he retired in 1960, and his son Richard succeeded him. In 1921, Michael donated funds to establish a clinic that provided free medical care to workers and their families. Later, these funds would become the Patrick and Anna M. Cudahy Fund.

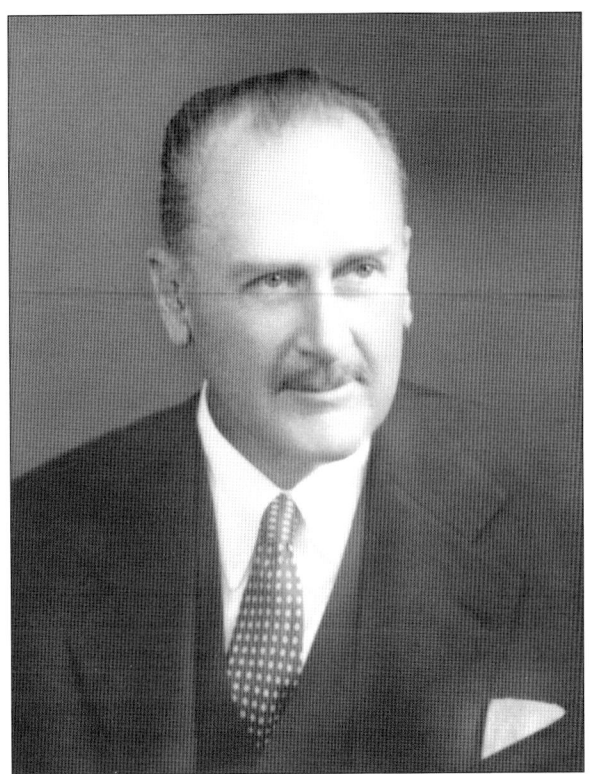

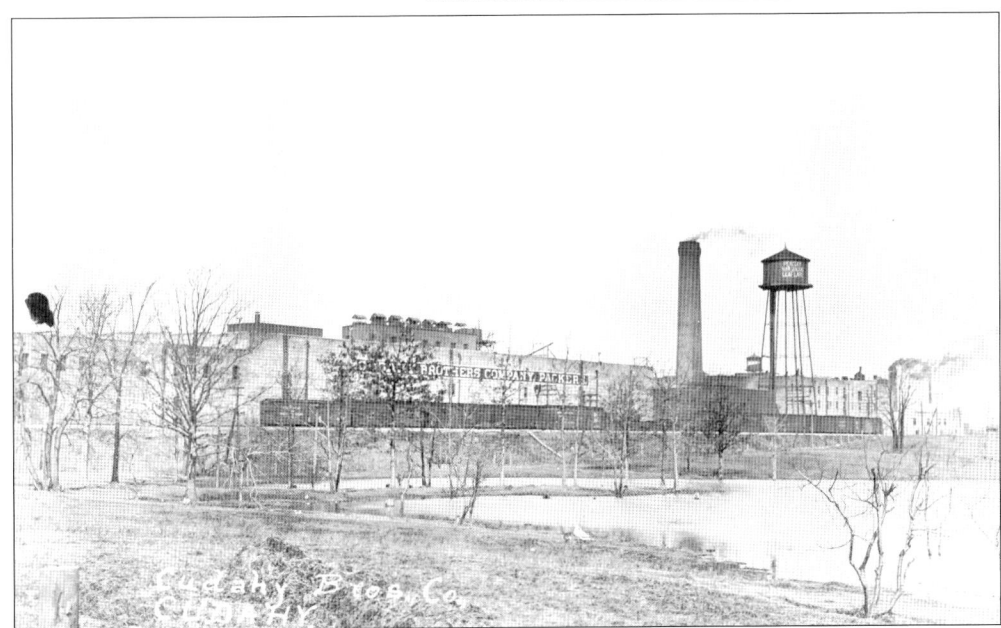

Construction of the Cudahy Brothers Company began in 1892. Costing almost $1 million, it became one of the largest meatpacking plants in the country. The plant was laid out on 77 acres, which included 40 acres for stockyards. It took over 4,000 railcar loads to deliver the materials purchased for the erection of 13 buildings: seven million feet of lumber, 10 million bricks, and 10,000 cords of stone.

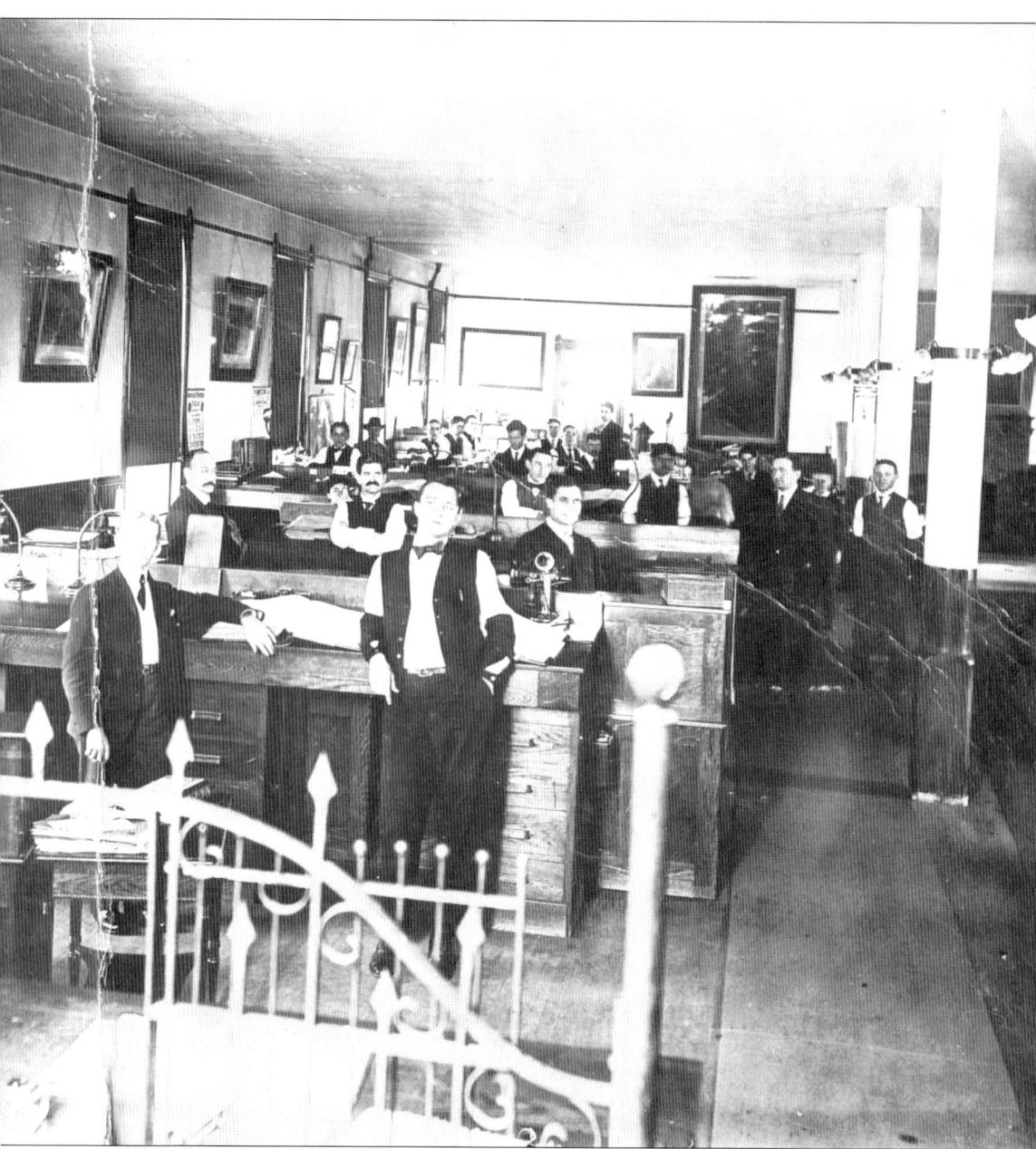
Although the foundation for the Cudahy Brothers Company office was laid early on, it was not completed until 1899. A temporary office was established on the third floor of one of the work houses. Vice Pres. Michael Cudahy's desk can be seen at lower right in this 1912 photograph.

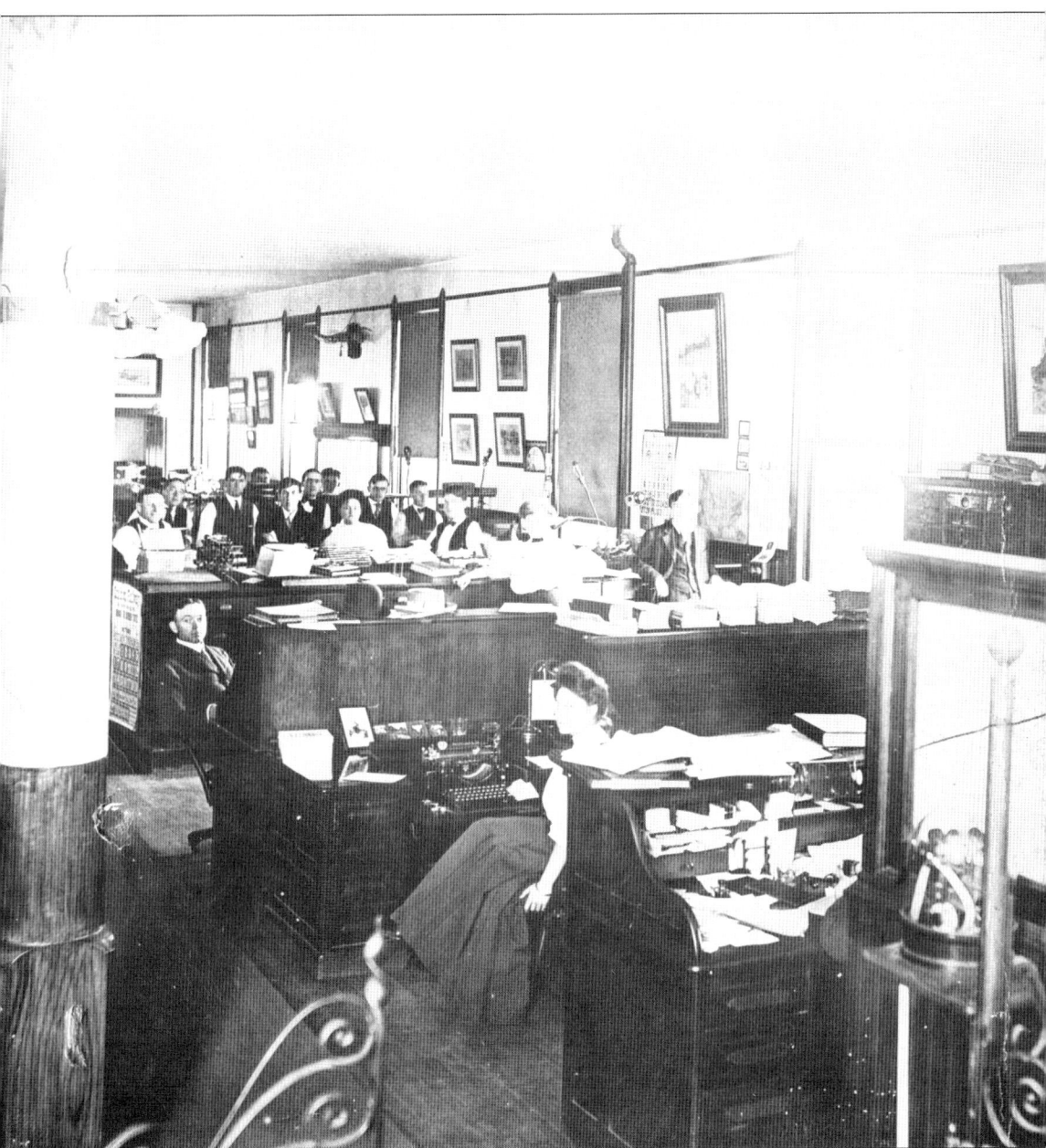
The office building's character has been preserved through many renovations, and it still serves its administrative function today.

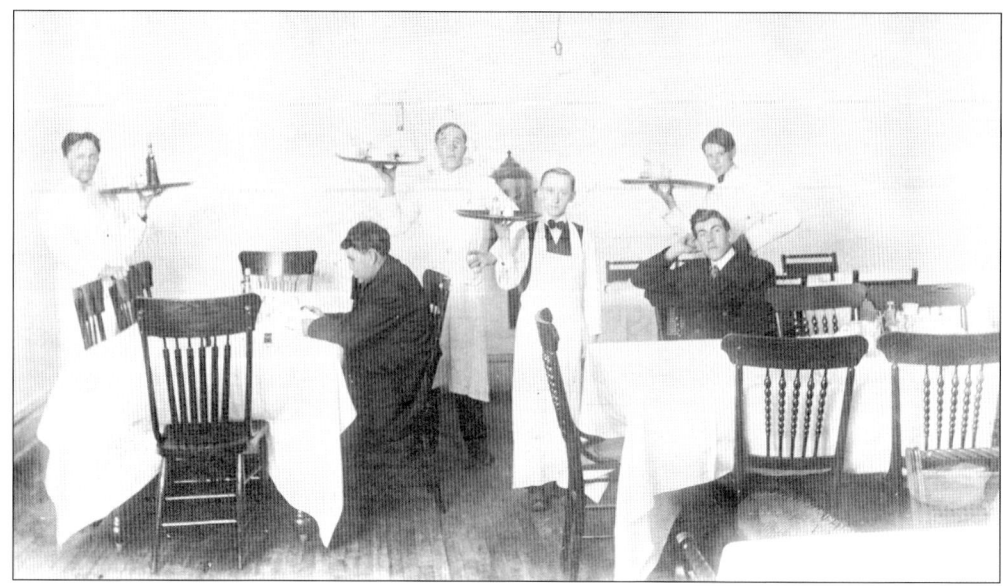

Michael Joseph Heffron (seated on right) is shown relaxing in the company's office dining room in October 1907. Fifteen years earlier, Joe Heffron's parents and five other families moved from Clintonville, Wisconsin, to Buckhorn in response to Patrick Cudahy's advertisement for work in the new plant. Heffron left the company to be the postmaster in 1915 and also served as an auxiliary US Secret Service agent during World War I.

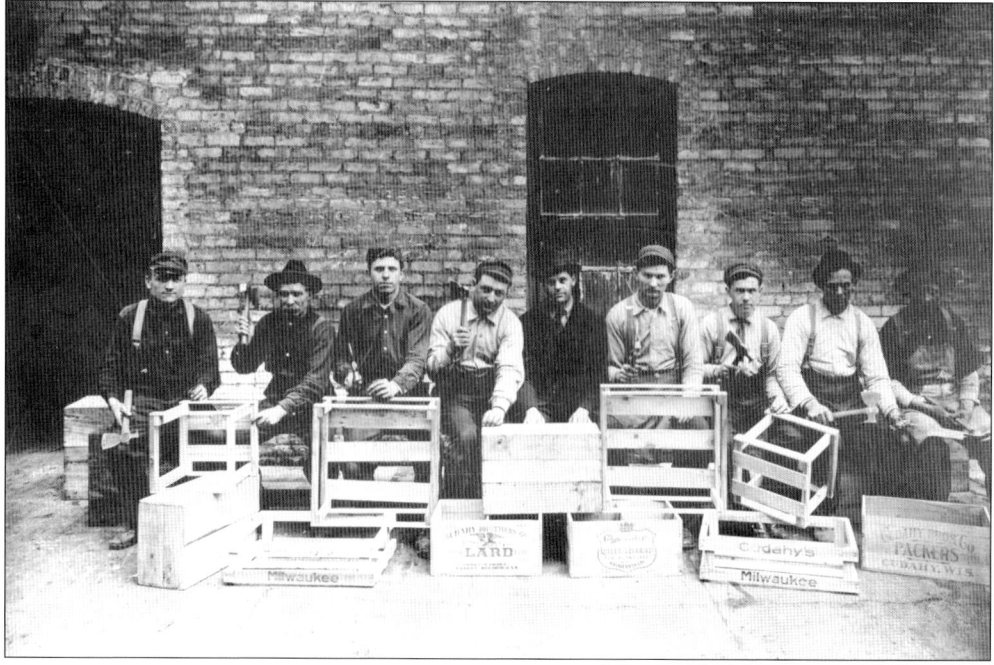

Shipping Department employees are shown constructing a variety of wooden crates for the company's lard products around 1915. When Patrick Cudahy was the superintendent for Plankinton and Armour meatpacking, he conducted many experiments and tests with hog renderings. In 1878, he invented an improvement for lard coolers and was issued patent number 220,811 on October 21, 1879. He later learned that the Milwaukee brewers had a similar system for cooling beer.

On August 12, 1919, Cudahy Brothers Company employees went on strike. Tensions were running high following several violent clashes between the striking workers and the company security force, and on August 20, approximately 279 Wisconsin state guardsmen were called in for four days to restore order. Strike breakers slept on the company property in this bunk area, known as the "Blackstone Hotel," after the well-known Chicago hotel.

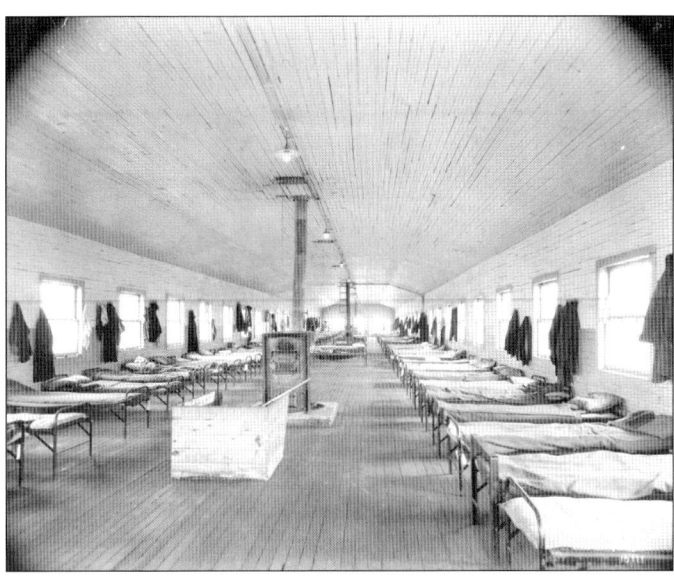

The Charles Hess Sausage and Provision Company opened in 1889 with a store at Third and North Avenues in Milwaukee. Hess made his own sausages in a separate factory but also sold Cudahy Brothers products, as can be seen in these window displays. In 1917, Patrick Cudahy purchased a controlling interest in Hess's company but continued operations under Hess's name until the company was dissolved in 1959.

In the early 1920s, Cudahy Brothers Company lost its main market of supplying Europe with cured pork when Congress enacted tariff acts to protect domestic manufacturers from foreign competition. Michael Cudahy focused on the American market with new products and advertising brands. S.F. Murphree, standing at far right, promoted Cudahy's Wisconsin Pure Food Products in 1926 at the Seller Grocery Company in Montgomery, Alabama.

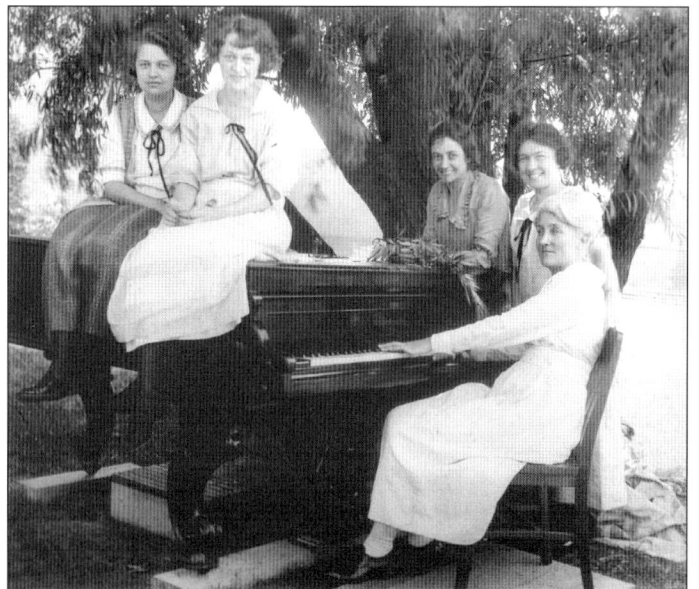

In the 1920s, employees enjoyed the company park adjacent to the office during their off time. Mattie Moriarity plays the piano for coworkers believed to be, from left to right, Genevieve McNamara, Leona O'Brien, Collette Phillips, and Rosa Cipella. Moriarity, chief telephone operator, was one of four winners in the statewide Good Will Contest of 1922. She won a trip to Europe in 1923 to tour famous battlefields.

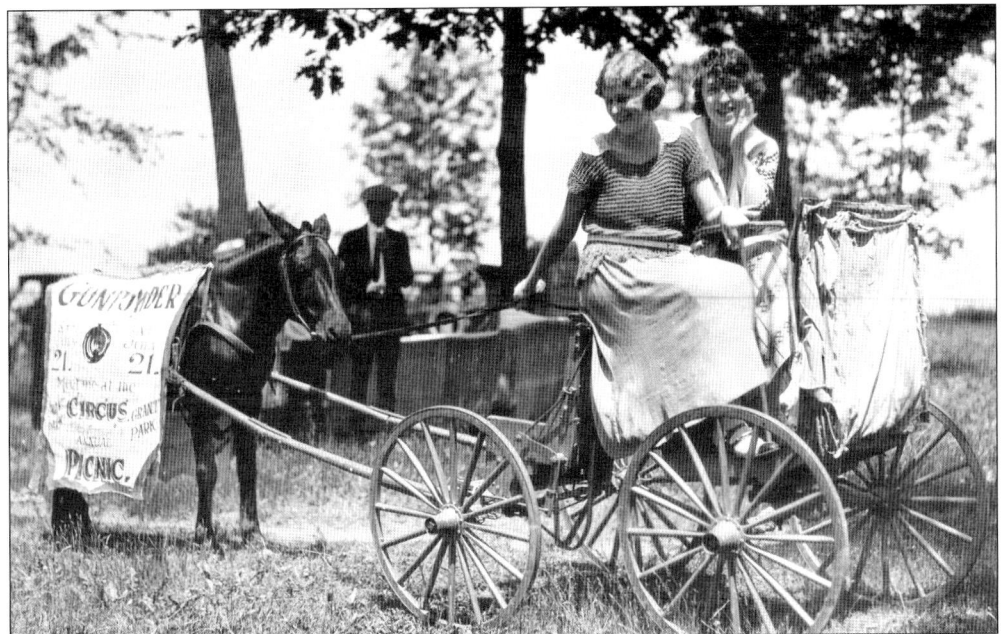

In 1923, Cudahy Brothers Company held the fourth annual company picnic for employees and their families in Grant Park, South Milwaukee. The picnic featured swimming, golfing, dancing, a baseball game, a circus, a tug-of-war contest, and a band concert. A children's parade started the festivities off in the morning, and an evening barbecue concluded them. Busses transported people from the plant to the park, and almost 10,000 attended.

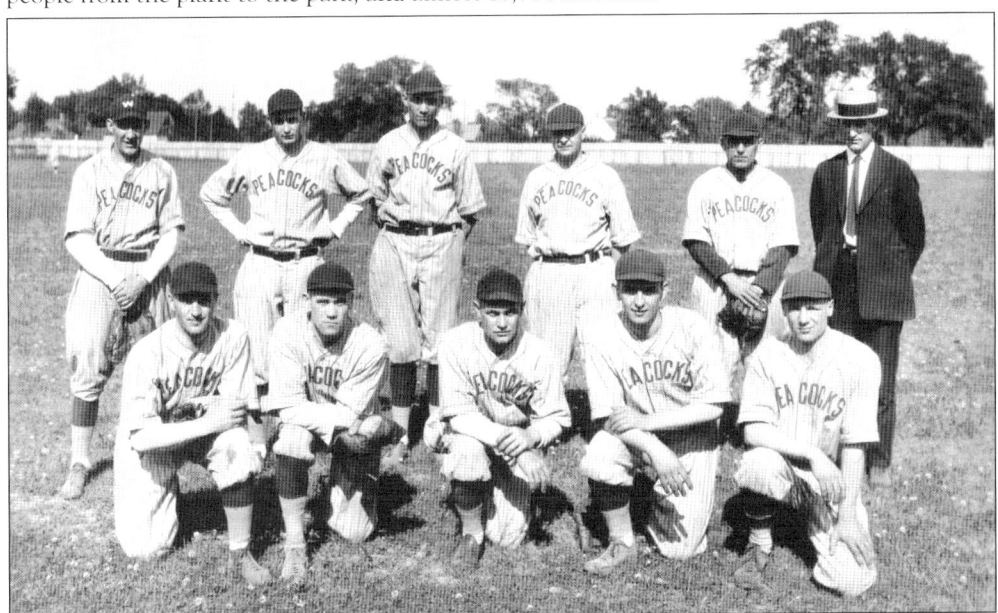

Cudahy Brothers Company sponsored a variety of teams in many different sports, including baseball, bowling, and tennis. This 1924 photograph shows the Cudahy Peacocks baseball team, named after the company's premier Peacock brand of meat products. Team members included W. Braby, Joseph Thoma, E. Heineman, Walter Bauman, A. Phillips, A. Hantschel, John Wagner, Robert Addis, Jack Wambach, Irvin Wittig, and G. Ludwig.

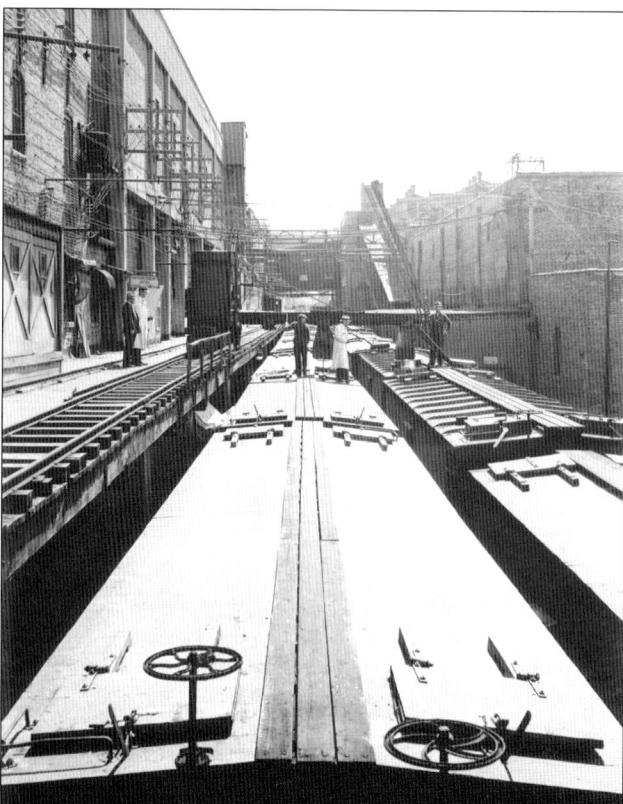

In the summer of 1924, Michael Cudahy started the Live Stock Improvement Department to encourage Wisconsin farmers to breed barley-fed hogs for bacon. In 1925, Cudahy, third from right, met with farmers gathered at Jefferson, Wisconsin, at the department's Yorkshire hog display. Displays were held in 18 Wisconsin counties to point out the advantages of raising lean hogs on home grown grains, dairy by-products, and alfalfa pasture.

When the original plant was constructed in 1892, a railcar shop was established to build "ice box cars" to transport meat using ice to preserve it. An ice car moved on the rails on the left of this 1924 photograph, distributing ice into the tops of the boxcars at the loading dock below. There was space to load up to 52 cars at one time.

18

Employees of the shipping department pose next to some of the company's fleet of Pierce-Arrow trucks outside the maintenance garage in April 1925. Dick Brodhagen stands next to the first truck at far left, and Stan Putz leans on truck No. 9. Putz was the supervisor of the shipping department, retiring in 1966 after 50 years of service. These trucks were used until the mid-1920s, when hard rubber tires were outlawed.

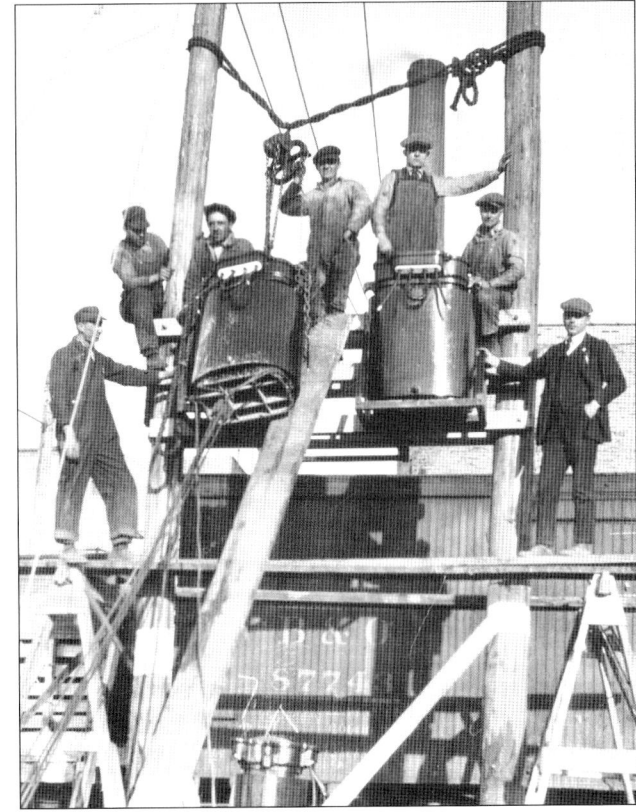

In the fall of 1934, employees put up transformers for an additional power line of 2,300 volts, necessary to power new equipment. Cudahy Brothers Company was said to be the country's first meat packing plant to install sharp freezers. The thermally insulated chambers of the freezer kept products at temperatures of 0 to -22 degrees Fahrenheit.

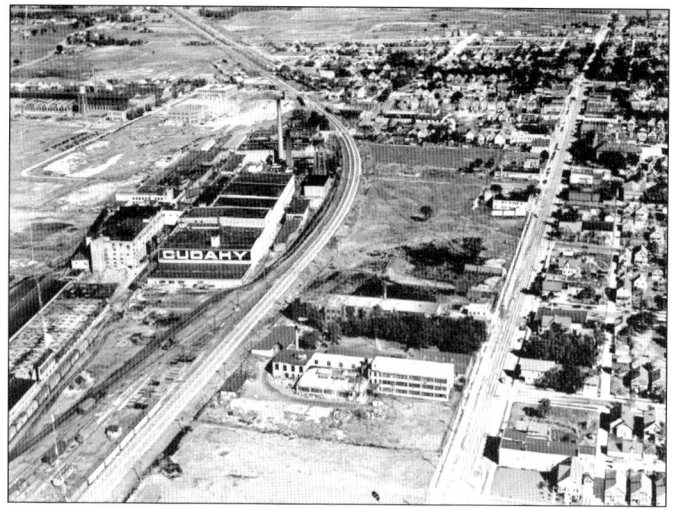

This 1937 view looking north illustrates how Cudahy designed his plant with two connecting rows of buildings along three miles of railroad tracks. At lower left are stockyards, adjacent to the five-story "hog hotel," which could house 10,000 live animals. The building labeled "Cudahy" included the cut floor. To the right of the plant is Packard Avenue and residential neighborhoods; at top left is the George Meyer Company.

Through the years, Cudahy Brothers Company, Patrick Cudahy Inc., and now Smithfield-Cudahy, WI have offered an amazing variety of product lines and brand names. Patrick Cudahy was fond of saying that his company used "every part of the pig except the squeal," and that was evident in the company's diverse product lines, including ham, bacon, sausage, pork loin, lunch meat, brains, chitterlings, sweetbreads, liver, lard, fat back, and much more.

The sliced bacon packaging department was state-of-the-art when this photograph was taken in the mid-1940s. Shown at the far end of the room are the US Slicing Machines slicers from which the bacon moved along to be weighed and then packed in cartons for shipment. In 1993, the company renovated the 100-year-old pork cut floor to become the precooked bacon department.

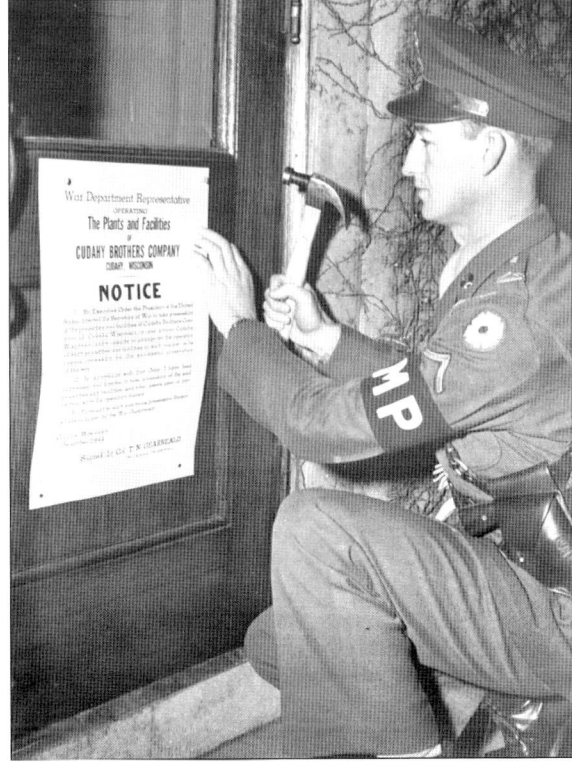

On December 8, 1944, Pfc. Virgil Duncan posts an order from President Roosevelt authorizing an Army takeover of Cudahy Brothers. The plant produced meat for troops stationed worldwide, and the seizure was intended to prevent an impending strike from disrupting the war effort. During the war, employees produced almost 173 million pounds of meat products for American and allied troops. Army control of the plant was relinquished in August 1945.

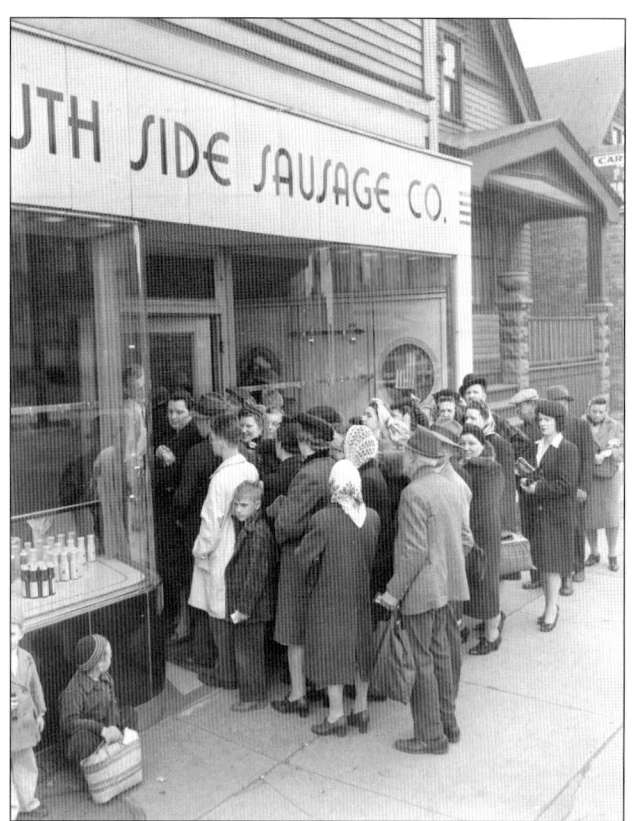

Customers line up outside the South Side Sausage Company on March 30, 1945. Meat was subject to rationing at the time and was in short supply. South Side Sausage was a large buyer of casings from Cudahy Brothers Company and also sold some of its pork products. Well known in Milwaukee for its sausages, South Side Sausage Company closed in 1981.

The body of Daniel Kuzminski returned home on December 2, 1947, after he was killed in Belgium on January 4, 1945. Kuzminski worked in the canned meats department. Over half of all plant employees, 862 in all, served in the military—one of the largest service records in Milwaukee County. Returning employees were given $100 bonuses in appreciation for their service, and families of servicemen who were killed were given cash grants.

Ace Foods Inc. was selected in 1947 to operate Cudahy Brothers Company's three cafeterias. In the plant cafeteria, from left to right, chef Glenn Trusty is assisted by cook Glen Mickelson and baker Hattie Hagen. Mary Vnuk and Caroline Buchholtz collected the money for the good, wholesome food offered at the lowest possible cost.

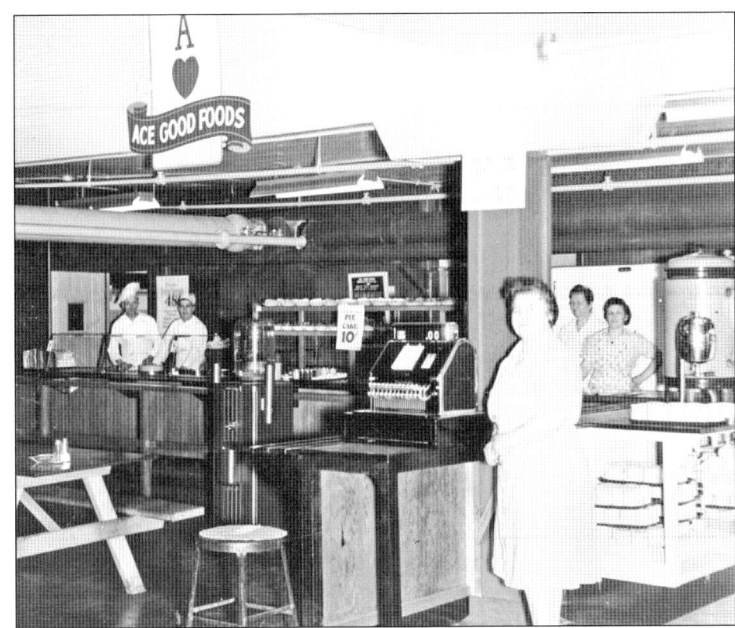

An employee's wife's suggestion to sell sliced dried beef in two- and four-ounce tins contributed to the expansion of one of Cudahy Brothers Company's smaller units. Employees working on this assembly line in 1947 packaged the product both in glass jars and in lithographed tins developed by the Continental Can Company. Every week, 50,000 cans were distributed to grocers, supermarkets, and retailers nationwide.

23

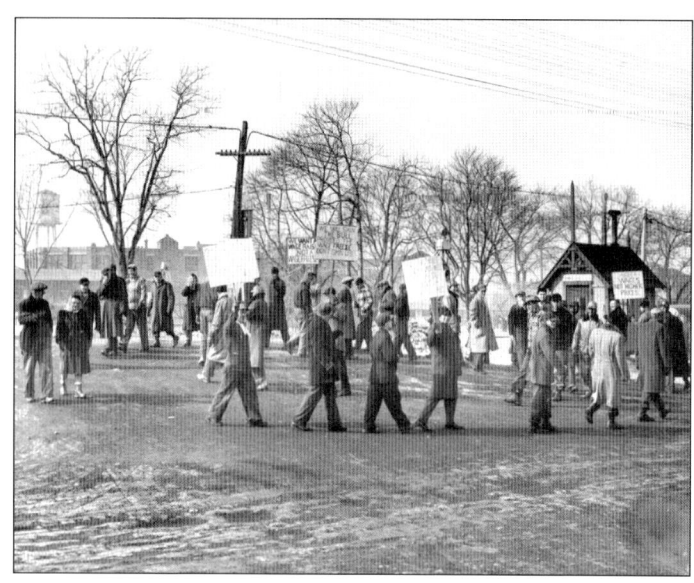

On February 9, 1951, members of Local 40, CIO Packinghouse Workers Union demonstrated in front of Cudahy Brothers, protesting wage freezes in the meat industry. Similar demonstrations were held by the union at various other packing plants, and a strike was averted when the freeze was temporarily lifted. By June, an 11¢ wage increase had been approved by the Wage Stabilization Board. (Courtesy of Wisconsin Historical Society, WHi-74820.)

In the brisk fresh sausage packing room, Peacock brand wieners are being packaged in 1950 by, from left to right, Beverly Grainger, Mabel Lekfield (back to camera), and Corky Korotke. Four years later, Frank Keogh, husband to Patrick Cudahy's granddaughter Mary, would introduce the phrase "smoked with sweet apple-wood" for Patrick Cudahy wieners. In 1957, Cudahy Brothers Company joined the celebration of National Hot Dog Week in July.

In 1960, Richard Cudahy, Patrick's grandson, became the third generation of the Cudahy family to assume responsibility for the company. Educated as a lawyer at West Point and Yale, Richard worked to streamline plant operations for the next 10 years. In 1971, he decided to sell the company to pursue his other interests. After working in private law practice for eight years, he was appointed a federal judge in 1979.

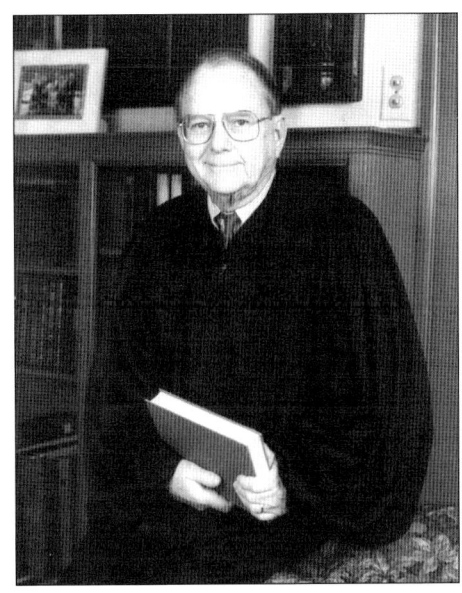

On May 27, 1969, three generations of Cudahy family members broke ground on a planned $4 million plant expansion. Pictured from left to right are Michael F. Cudahy, board chairman; Michael's son, Richard D. Cudahy, president; and Michael's grandson, Richard Cudahy Jr. The man on the far right is Wisconsin governor Warren Knowles. Although the expansion never was completed, the photograph illustrates the family involvement in the company.

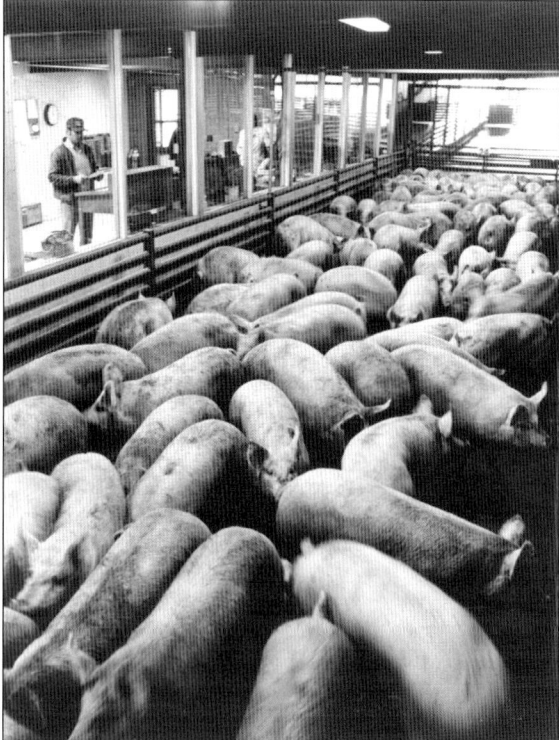

By advertising for workers in a variety of foreign language newspapers, Patrick Cudahy attracted a large group of immigrants to work at his plant. Diverse nationalities were represented, including Polish, German, Irish, Hungarian, Czech, Moravian, Slovak, Bohemian, and Croatian. This multicultural heritage continues to this day, with over 30 languages spoken in the plant.

Yard foreman Edgar Cerbins is pictured weighing newly arrived hogs in 1978. In the late 1970s, between 5,000 and 6,000 hogs were delivered to the plant each day. The company built new concrete and steel stockyards in 1976, allowing approximately 1.5 million hogs to be processed annually. Hog slaughtering operations ceased in 1988 as market conditions changed and workers went on a lengthy strike.

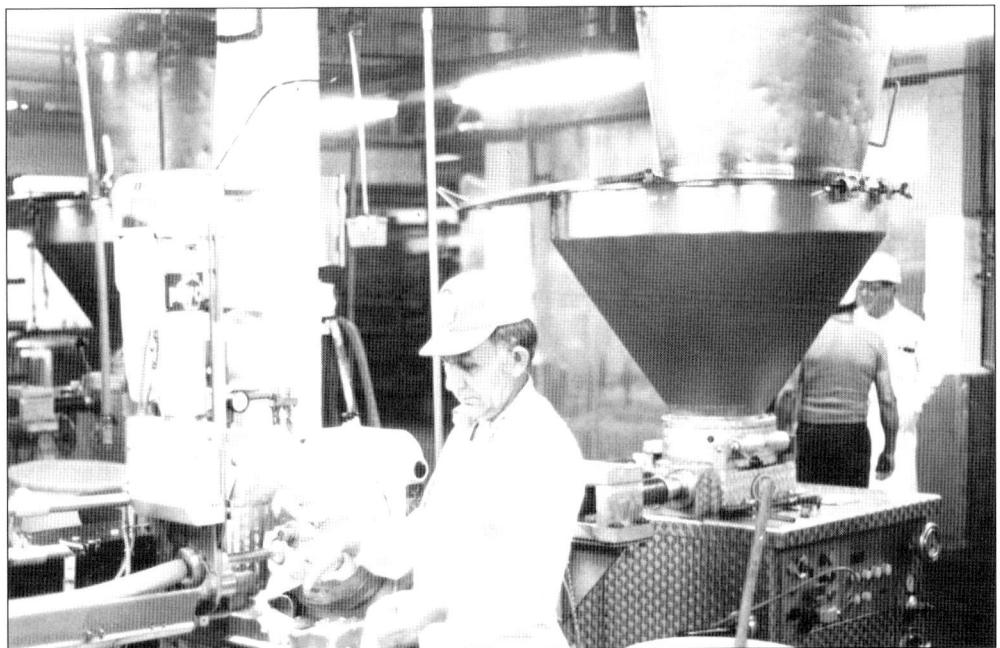

Ed Rogalski is working in "the Kitchen" in this photograph from October 1980. The Kitchen is an old nickname for the sausage manufacturing department, which produces both dry and fresh sausages. Rogalski stuffed casings with the meat contained in the 600-pound funnel-shaped bucket behind him. The output of the machine was 550 to 750 sausages per hour. The sausages were then hung on a metal rack known as a "tree."

Roger Kapella became president of Patrick Cudahy in January 1986. Challenged with modernizing an aging facility while regaining profitability, Kapella oversaw many changes during his tenure. The company endured a divisive 28-month strike, the shutdown of its slaughterhouse operations, and a bankruptcy filing before a seven-year, $100 million expansion and modernization effort would result in it emerging as an industry leader in the 1990s. Kapella retired in December 2004.

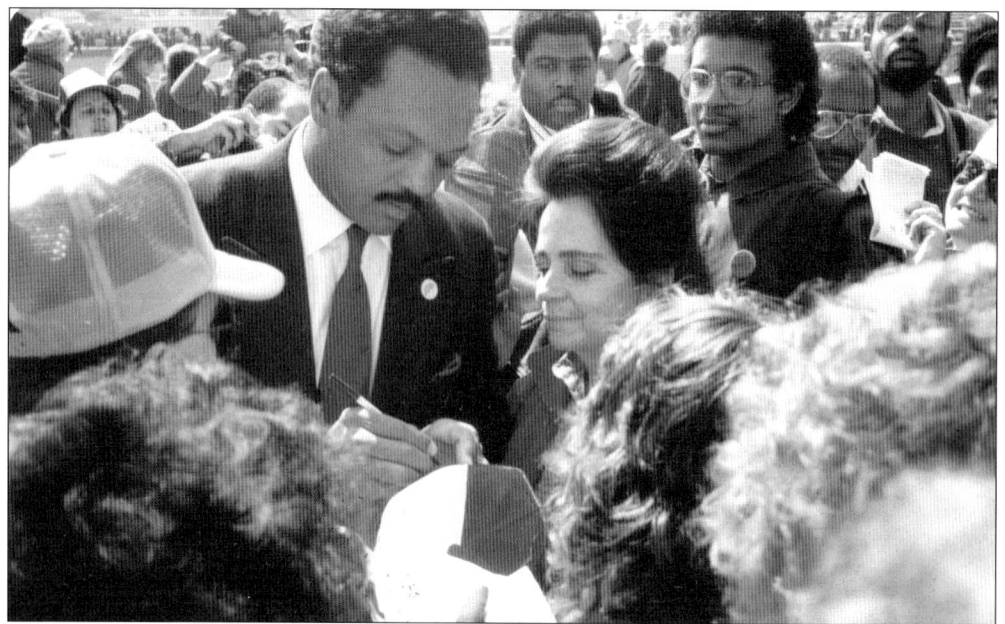

On January 4, 1987, about 800 workers went on strike for 28 months after rejecting wage concessions. Emotions ran high as replacement workers were hired. In April, Rev. Jesse Jackson visited to lend his support for the cause, leading about 3,000 on a mile-long protest march through the streets of Cudahy. Ultimately, the strike was ended in April 1989, with both the workforce and wages reduced by about 20 percent.

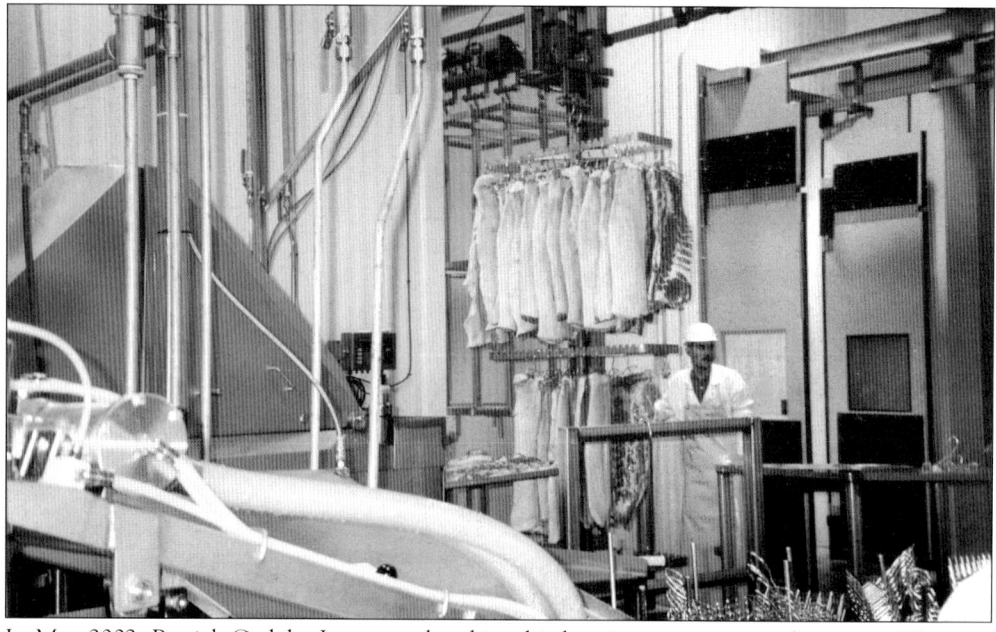

In May 2002, Patrick Cudahy Inc. completed its third major expansion in five years. The new building added about 110,000 square feet to the facility and housed a state-of-the-art bacon and sausage processing area. The company store and human resource departments were relocated as well as the employee entrance to the plant. Additional microwave lines were also added to increase production of the company's precooked bacon products.

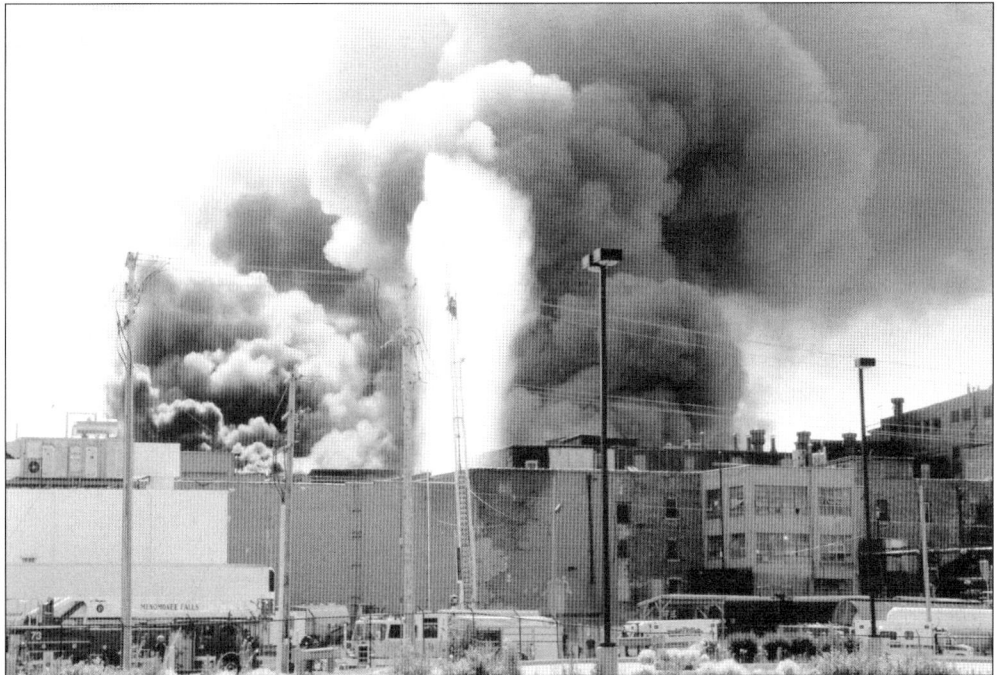

On July 5, 2009, two men fired a military-grade rocket that landed on the roof of one of the buildings at Patrick Cudahy Inc. The flare sparked a fire that burned for three days, destroyed four buildings, and forced the evacuation of nearby businesses and residences. More than 150 firefighters from 30 departments responded to the call.

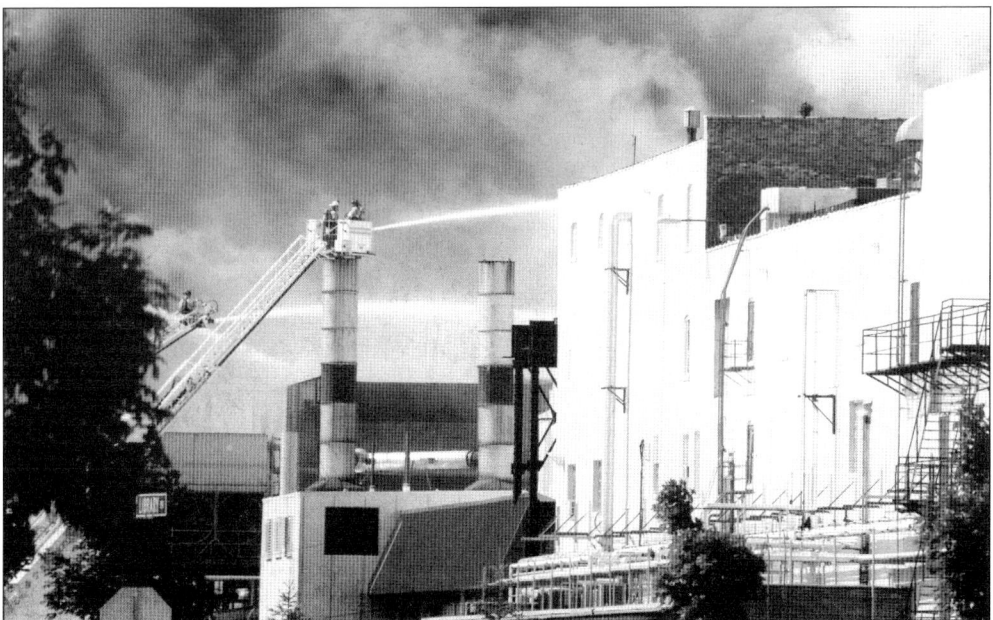

Ultimately, the fire cost the company $326 million in losses. The 2009 fire occurred just over 100 years after the company's first major blaze, which took place on September 3, 1906, when the beef house and lard refinery were destroyed by fire. It took about two months to rebuild those sections, which were back in operation by November 14, 1906.

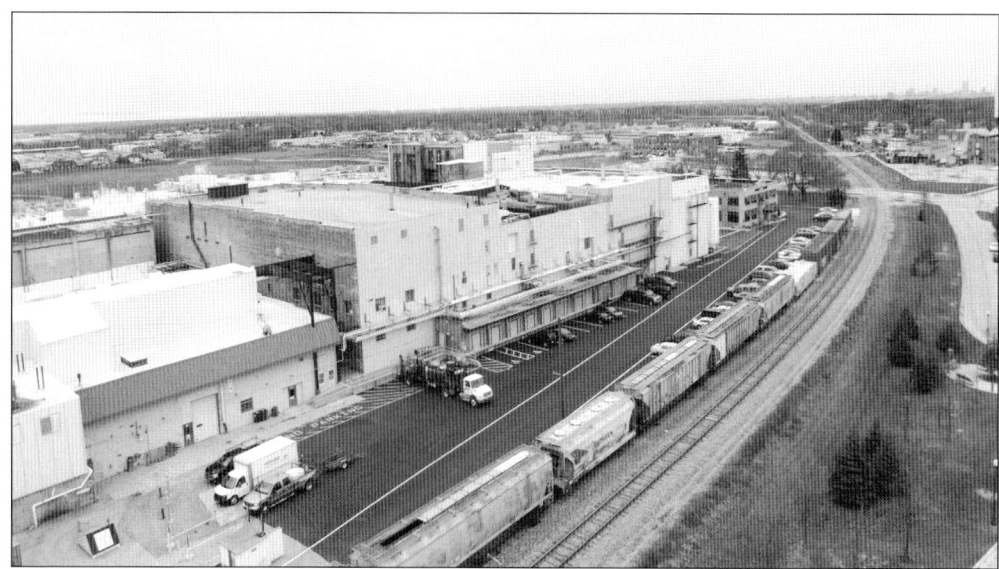

This 2014 photograph shows the northern portion of the Patrick Cudahy property. Proximity to the rail lines was critical in the company's early days to get the products to market in a timely manner. Today, transportation options also include semi-trucks and airplanes, which deliver the company's products all over the country. Although Patrick Cudahy is deeply rooted in the past, the company is constantly modernizing and adopting new technologies.

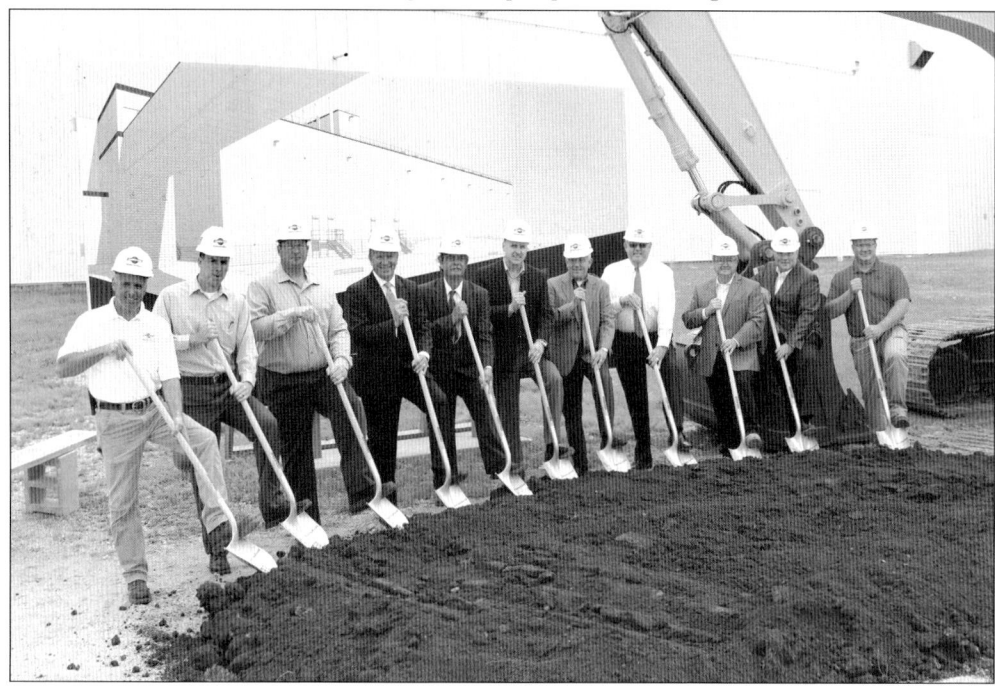

On August 20, 2015, Smithfield-Cudahy, WI broke ground on a $13 million expansion. The 12,500 square foot addition will include four new smokehouses and two dry rooms and will increase production capacity by three million pounds annually. Pictured from left to right are Marvin Hazlett, Joe Malchow, Mark Storandt, Dean Basten, John Hohenfeldt, Dan Kapella, David Amacher, David Voss Jr., Gene Bridges, Tom Kennedy, and Eric Grams.

Two

Patrick Fulfills His Business Vision

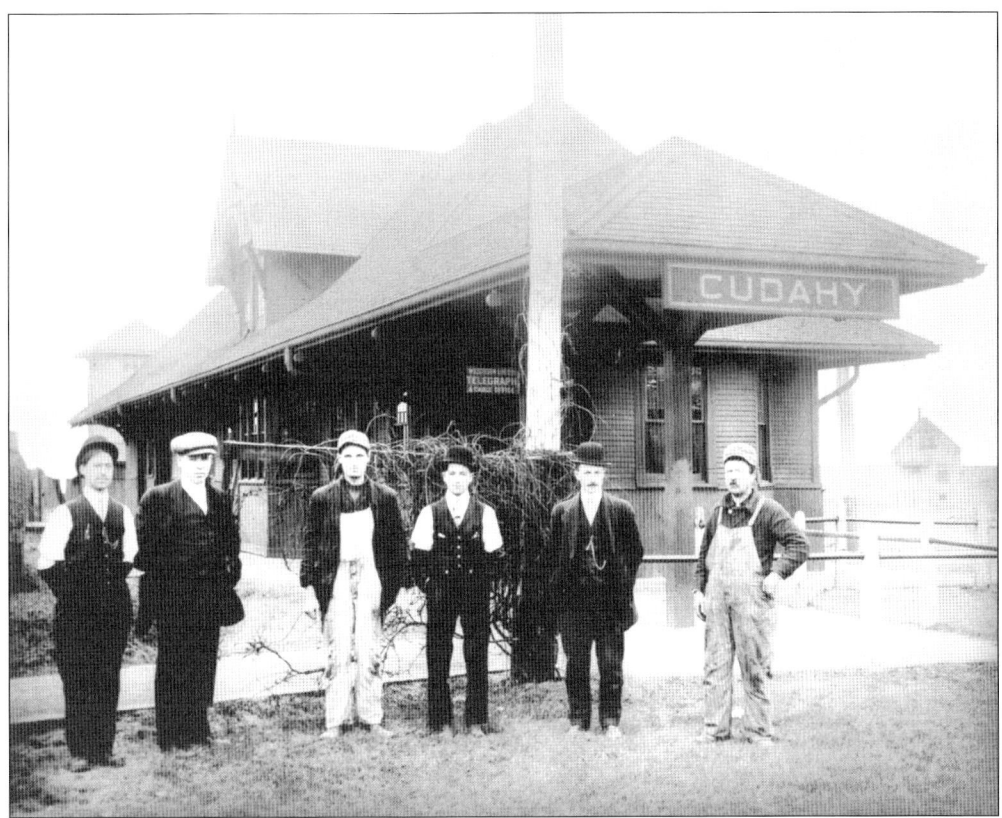

It was the Chicago & Northwestern Railway that gave Patrick Cudahy's new town the name of Cudahy. He had convinced the company to build this depot on a parcel of his land near the packing plant in 1892. These employees are pictured in front of the depot after an addition for freight was built in 1907. The Cudahy Depot was in use until 1956, when passenger service was discontinued.

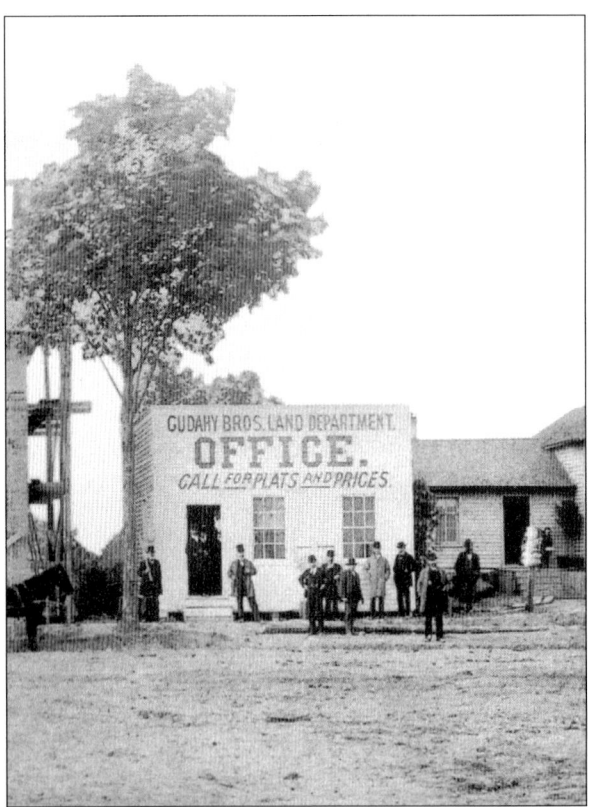

The Cudahy Brothers Land Department started selling the land that Patrick Cudahy purchased for his town on September 17, 1892. As the workforce grew at the plant, the department built more cottages to help meet the housing shortage. The Milwaukee real estate firms of Bohmann and Kroeger, Gilbert S. Joyce, Hugo Koeffler, Mabbett and Jefferson, and Sivyer and Betz were also selling lots and acres in Cudahy.

The railcar shop on Whitnall Avenue has been in operation since 1893, when Patrick Cudahy built it on the west side of the plant. In his autobiography, Cudahy relates how it took courage to purchase the first 50 refrigerator cars, at $450 each, during the Panic of 1893. By 1912, he had increased his shipping fleet to 266 train cars. The cars were marked Cudahy-Milwaukee or Peacock Refrigerator Lines.

After Patrick's death in 1919, his son Michael organized the company's railroad division into a separate business, the Northern Refrigerator Car Company. He purchased 500 railroad cars the first year and renovated the yard in 1924, building an indoor repair shed. His employees are pictured here in front of the cavernous structure, some of them displaying the tools of their trade.

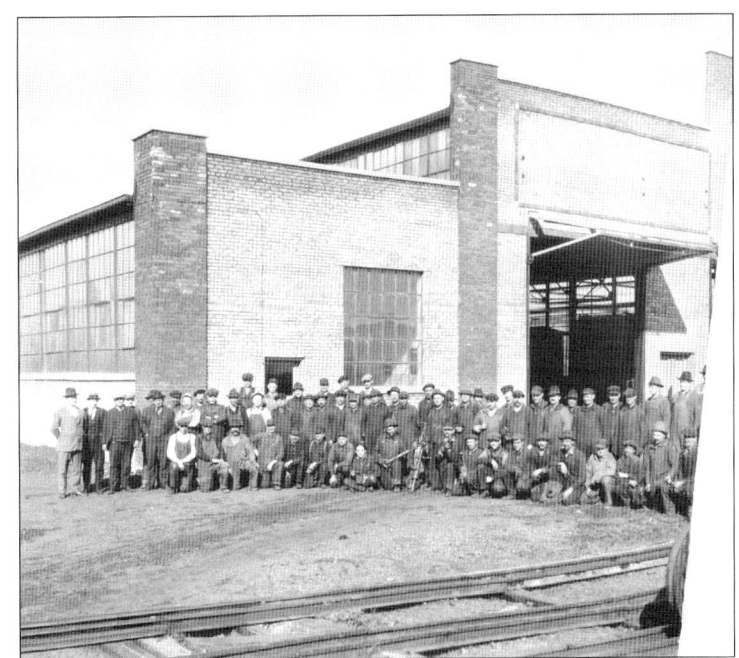

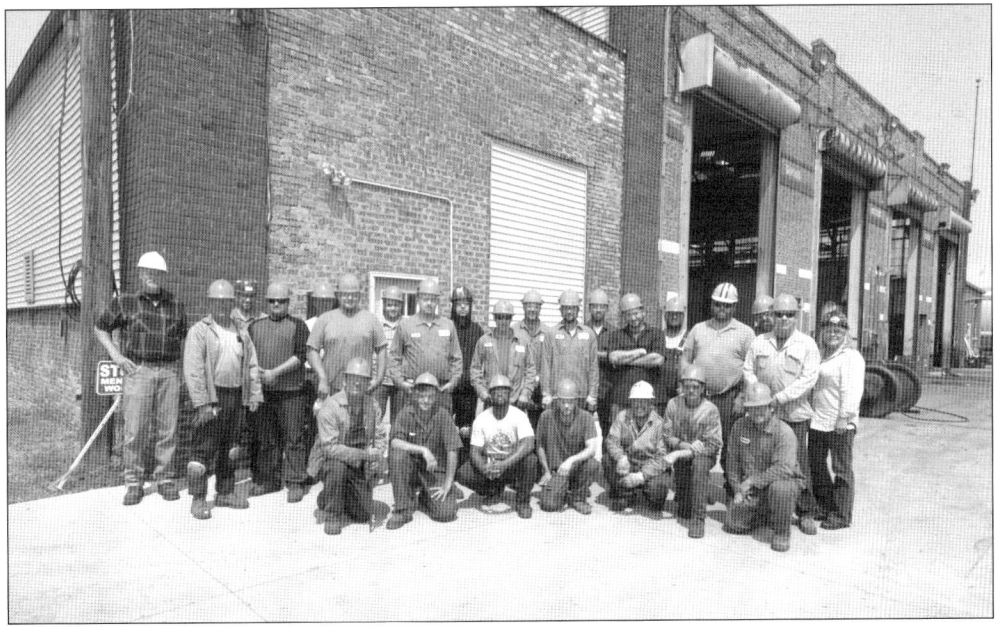

In November 1928, Michael Cudahy sold the railroad company and its 1,800 cars to the Merchants Despatch Transportation Company for over $4 million. A stipulation of the sale guaranteed the Cudahy Brothers Company preferential use of the refrigerator cars at $5 a load for 10 years. After the Merchants Despatch Transportation Company ownership, there were several other owners, including the Chicago & North Western Transportation Company and the Cudahy Car Shop Inc. In 2012, the business was purchased by Watco Companies LLC. Watco employees are shown here in front of the same building erected by Michael Cudahy in 1924. GBW Railcar Services now operates the yard with a storage capacity of 250 cars. The employees can handle more than 140 cars per month.

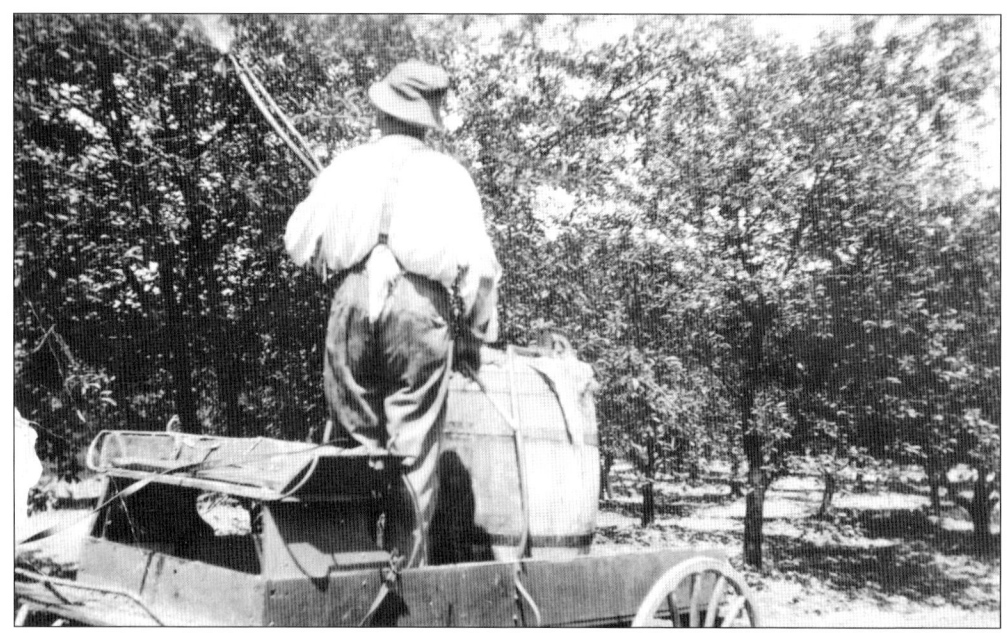

Barney A. Eaton is shown spraying his fruit trees and plowing his berry fields in these two photographs. Lakeside Fruit Farm on Lake Drive was widely known as one of the best cherry orchards in Wisconsin. Eaton established his farm in 1883 on lands that his father had purchased in the mid-1800s. In addition to cherries, the farm also supplied apples, strawberries, and raspberries. The lands where the farm once stood are now part of Sheridan and Warnimont Parks. Eaton was active in his community, serving on the school board for 17 years. In 1895, he was elected the first president of the Village of Cudahy. Eaton also served in the state assembly from 1894 to 1898 and in the state senate from 1898 to 1905. He was elected the third mayor of the City of Cudahy in 1910 and served until 1912.

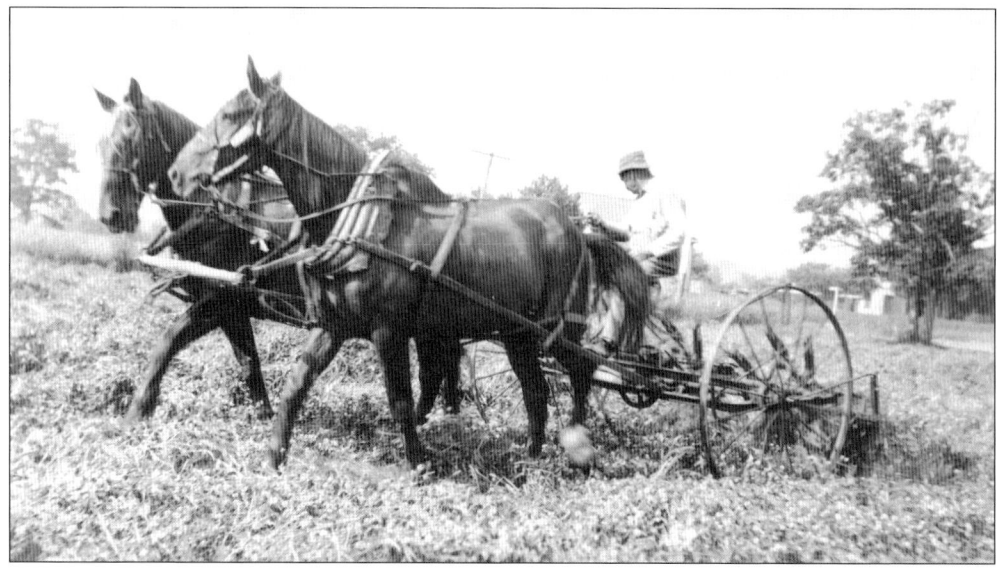

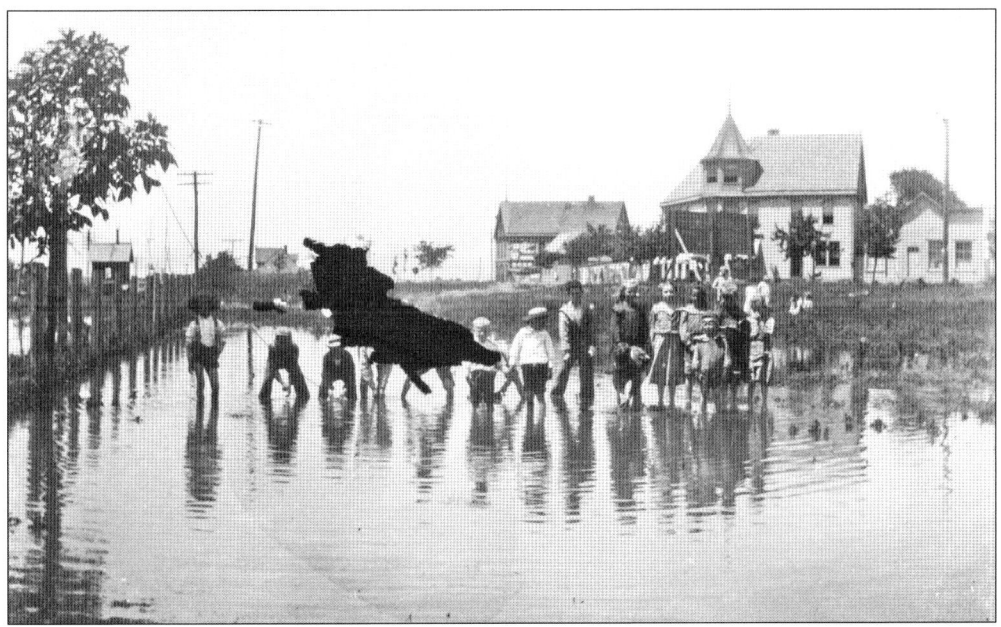

Brothers Alfred and George Ponto are shown playing with a group of children in a flooded field near the Ponto Hotel in the mid-1890s. Built by their father, Theodor, in 1892 at Patrick Cudahy's suggestion, the hotel and saloon was one of the first businesses in Cudahy and housed many packinghouse workers.

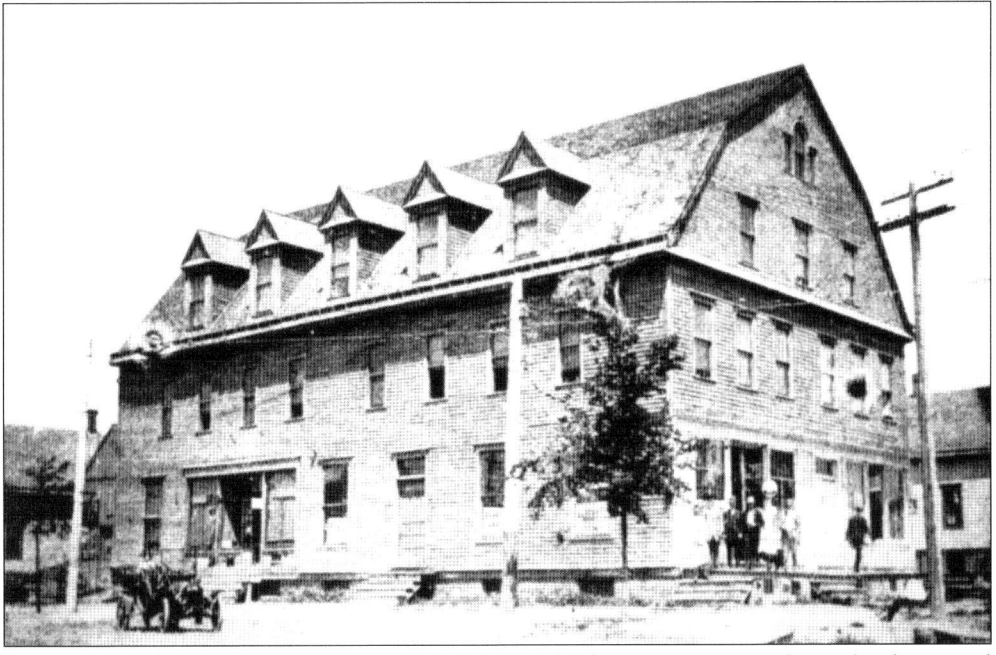

Located on the northwest corner of Packard and Plankinton Avenues, the Columbia Hotel was one of the earliest buildings in Cudahy. It housed many employees of the Cudahy Brothers Company plant, provided space for retail businesses, and was the site of many social events. The hotel changed hands several times over the years, eventually falling into disrepair. It was razed in 1920 after being deemed unfit for occupancy.

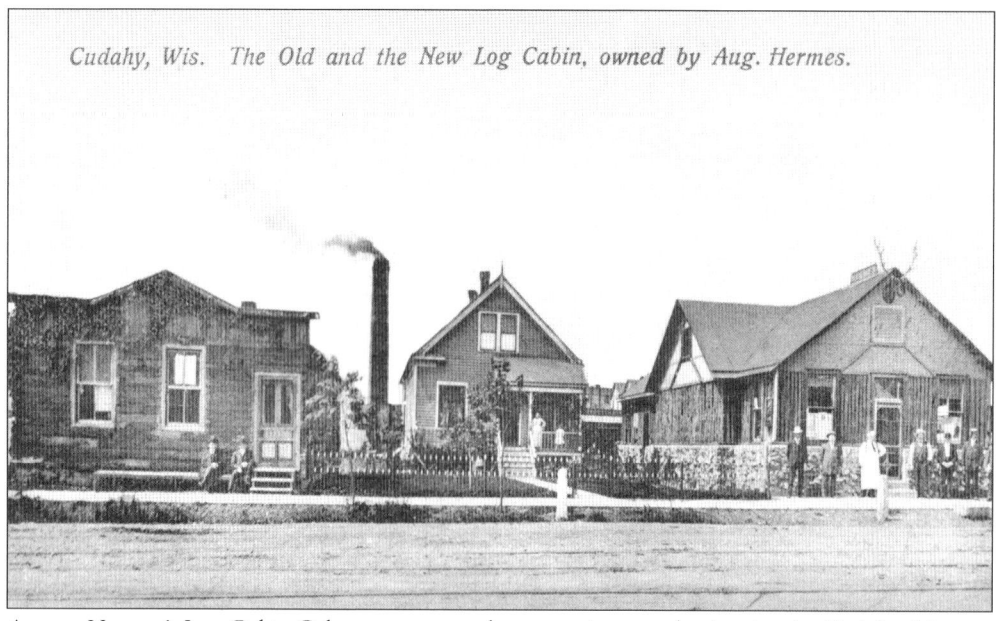

August Hermes's Log Cabin Saloon was an early entertainment destination in Cudahy. Hermes opened his first log cabin saloon in 1898. In 1905, he built his "new log cabin saloon" two doors down from the old. The new saloon was decorated with a variety of fascinating items from Hermes's personal collections. The only public bathing rooms in Cudahy were housed in the basement of the new saloon.

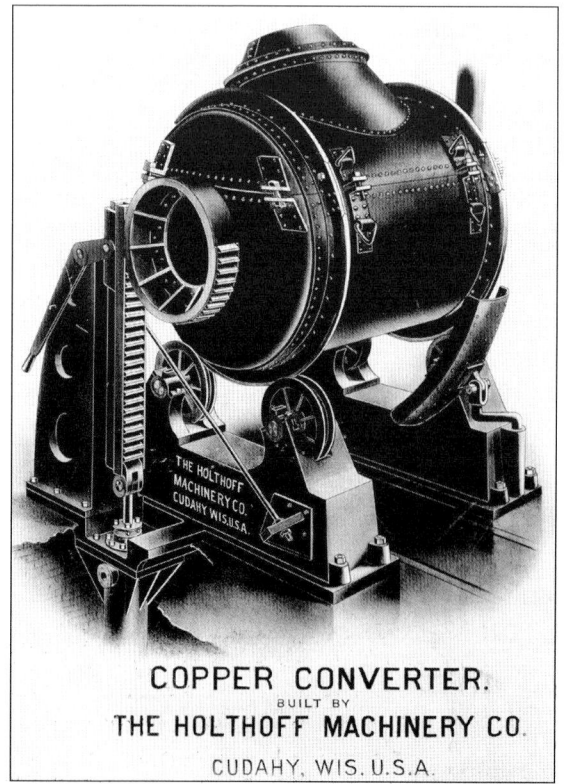

Incorporated on October 19, 1901, Holthoff Machinery Company was one of the earliest industries to locate in the newly-founded Village of Cudahy. Patrick Cudahy served on the board of directors of the gas engine manufacturer. The company was bought out by Benjamin Guggenheim of the Power and Mining Machinery Company in 1903.

A 1,400-horsepower, four-cylinder gas engine rests on test blocks in this 1904 photograph from the Power and Mining Machinery Company. Established in 1903 on the site of the former Holthoff Machinery Company, the Power and Mining Company manufactured mining products, engines, and pumps and was a major employer in Cudahy. Company president Benjamin Guggenheim was lost on the *Titanic* in 1912, four years before the company was sold.

Milwaukee Rubber Works was incorporated on March 3, 1903, with financing provided by a group of Milwaukee capitalists. The plant was in operation by September of the following year, erected in the field that was once known as Pat Cudahy's pasture, thanks to its proximity to the Cudahy Brothers Company packinghouse. The company produced tires for bicycles, automobiles, and carriages as well as horseshoe pads, valve packing, and other mechanical goods. In October 1904, extensive additions were made, but the business was hampered by the managers' inexperience in the rubber trade. On March 21, 1906, a petition for involuntary bankruptcy was filed against Milwaukee Rubber Works by some of its largest investors. It was sold on May 6, 1907, and reorganized under the name Federal Rubber Company. At that time, additional land was purchased in anticipation of tripling the plant's capacity.

Perched atop a 140 foot bluff, the smokestacks of the Milwaukee Vinegar Company and Red Star Yeast plants served as a navigational aid for freighters in Lake Michigan for over 50 years. Parent company National Distillery Company purchased the former site of the Fink and Fehrlein Chemical Company in 1903 and operated the plants until 1958, when the company sold the land to the Milwaukee County Parks system.

The Federal Rubber Company produced rubber tires, inner tubes, hoses, and even gas masks during World War I. The headquarters and manufacturing plant were located in Cudahy, with nationwide distributorships. The company was one of the city's major employers, with over 1,500 workers manufacturing 18,000 tires a day by the late 1920s. Employee camaraderie, a variety of social activities, and high wages made it a desirable place to work.

In 1911, Federal Rubber organized a fire department, pictured in 1917. The department was put to regular use both in dousing fires on company property and in helping with large fires in the City of Cudahy. Most members lived near the factory and were on call 24 hours a day, seven days a week. Hot rubber, along with various chemicals, made small fires a common occurrence.

Women were a valuable part of the Federal Rubber workforce, especially during World War I. After a 1917 company newsletter chastised their male counterparts for rough language and suggestive remarks, a separate rest room furnished with comfortable chairs, reading materials, and a phonograph was established for the women. From left to right, employees Rose Gray, Leona Kramer, Rose Gresk, Mrs. Bruttig, and George Ponto are pictured in this 1919 promotional image.

Ambrose Raphael (center) and an unidentified coworker lower filled tire molds into the heater for vulcanization in this 1920 photograph from Federal Rubber. The company was one of the most modern tire plants in the country when its parent company, Fisk Rubber Company, went bankrupt in 1929. Over 1,200 employees lost their high-paying jobs. The equipment, buildings, and 50 acres of land were sold at auction in 1933.

Waldemar Helmholz established the Helmholz Mitten Factory in Milwaukee in 1905. Helmholz was married to Patrick Cudahy's daughter Mary Irene. When the company outgrew its Walker's Point location, Patrick encouraged Helmholz to move to Cudahy, and a new plant was built on Packard Avenue in 1910. The business expanded into gloves and shoe making in subsequent years. In 1934, Helmholz sold the property to Scherer Leather Company.

"Ingeco" OIL Engines

Manufactured along lines you are familiar with. Side shaft with mechanically operated valves and built on magneto. Operates on ordinary **Kerosene;** cheapest grade fuel.

Branch sales offices, stores and distributing depots in all principal cities.

International Gas Engine Co., 130 Holthoff Place, Cudahy, Wis. (Suburb of Milwaukee)

Oil, Gasoline, Gas.
Standard Horizontal
6 to 60 h. p.

The International Gas Engine Company (Ingeco) was established in 1912 as a subsidiary of the International Steam Pump Company. The company manufactured gas engines ranging from .5 to 350 horsepower. In 1916, the company was taken over by the Worthington Pump and Machinery Corporation but continued to produce engines under the Ingeco brand name until 1920.

This 1960s aerial photograph shows the Ladish Company's 165-acre campus. Ladish was known worldwide for its expertise in large scale, high strength, and specialty forgings. Partners Herman Ladish and John Obenberger moved their drop forge business to Cudahy from Milwaukee in 1912 as their automotive parts line expanded. The company continued to grow, eventually becoming one of Cudahy's largest employers. Allegheny Technologies Incorporated purchased the Ladish Company in 2011.

A Ladish employee bores bolt holes for a flange on a multi-spindle drill. Ladish began forging pipe flanges in 1932, as the business was struggling during the Depression. The fittings division provided a steady sales stream and a hedge against business downturns. Forty years later, the company was offering over 5,000 different flanges, fittings, elbows, and the like, ranging in size from a few ounces to multiple tons.

After the stock market crash of 1929, Ladish struggled to turn a profit as the country's economy deteriorated. In the early 1930s, the company began to place a new emphasis on machining in addition to forging, enhancing the value of its finished products. Machining parts remains a key strength of Ladish today. An employee is shown here machining a dome, perhaps for use in the aerospace, defense, or power industries.

Ladish was a vital part of the United States war effort during World War II, producing a variety of forgings for airplanes, tanks, trucks, tractors, and engines. Employees staffed three shifts, six days a week, and often worked overtime and on Sundays to meet the demand. The plant was expanded, security was dramatically increased, and women became part of the production line. At its wartime peak, Ladish employed 3,400 people.

The July 1944 cover of *Ladish News* pictures Ensign Warren Ponto (left) and Corporal Del Hensen, two of over 800 Ladish employees who served in the armed forces during World War II. The company granted employees a leave of absence, offered wage dividend and vacation pay checks, and guaranteed them a job when they returned. Servicemen were mailed the monthly newsletter, and many stopped by the plant when home on leave.

A Ladish metallurgist is shown here working in the company's chemical lab in the early 1950s. The Ladish metallurgical department was one of the most complete in the industry during and after World War II and maintained an extensive library. Metallurgical engineers created, tested, and patented the super strong, lightweight alloys needed for aerospace applications as well as the new die steels needed to forge them.

An array of specialized machines can be seen on the Ladish Company work floor in this 1950s photograph as employees worked to manufacture parts. At its 1956 peak, the Ladish plant in Cudahy employed 5,996 people in what was often a family affair, with multiple extended family members working for the company.

When Ladish's No. 85 counterblow hammer was completed in 1959, it was the largest in the world, increasing the company's maximum forging capability from 10,000 to 50,000 pounds. Designed by an engineering team led by Otto Widera, the No. 85 hammer stands taller than a three-story building. Each blow delivers a staggering 125,000 meter kilograms of energy, which can be heard—and felt—in nearby neighborhoods when in operation.

Workers forge a double valve body steam chest in the No. 85 counterblow hammer at Ladish in the 1960s. After the metal is heated to a specified temperature, it is shaped by two dies synchronized to meet in the middle, like jaws snapping shut. Ladish could produce large-scale steam chests as a single unit because the hammer was so large. The company became a major supplier for power plants worldwide.

Comprised of carbon steel, this seamless rolled ring weighed 50,000 pounds and stood over 23 feet tall when it was created in the 1960s. Ladish was the only company in the country able to produce the huge seamless rings, making it a critical supplier for the US aerospace industry through the years.

Ladish rolled rings were used for the forward and aft flanges in the nozzle of this three-million-pound solid fuel rocket motor, shown in its silo prior to firing. Ladish supplied the motors for the Titan rockets as well as the booster rockets that lifted the space shuttle into orbit.

47

This wooden model of a Boeing 747 flap track dwarfs the model in this late 1960s photograph. The aviation industry was, and remains, a major market for Ladish, with the company producing critical components for both commercial and military aircraft. About 50 Ladish forgings were used on each 747 commercial jet, from the landing gear to the engine to the airframe.

A Ladish employee stands next to two huge 70,000-pound t-shell components for a nuclear steam generator system in this 1960s photograph. The expansion of nuclear power in the United States afforded an opportunity for growth for Ladish. The company supplied necessary components to the power plants, ranging from fittings to forgings, while ensuring their safety and reliability.

Forging can be a dangerous trade, as evidenced by this photograph taken after an explosion at Ladish on May 12, 1966. A spark in the building that housed equipment for manufacturing acetylene gas for welding torches touched off the massive explosion. The blast leveled the building, scattering debris for some 90 feet and shattering the windows in two nearby homes. Ladish welding supervisor Frank Wederath was killed in the explosion.

The Ladish Company celebrated 100 years in the forging business with a company anniversary picnic in 2005. President and CEO Kerry Woody is shown at left with retired Ladish employee Thomas Buresh. Woody served as CEO from 1998 through 2009, after having worked at various positions in the plant since 1975. Buresh worked as a hydraulic repairer from 1953 through 1991 and volunteered in the metallurgical library after he retired.

THE MAMMOTH WORTHINGTON GAS ENGINE WORKS WHERE THE FAMOUS WORTHINGTON KEROSENE ENGINES ARE MADE. LOCATED AT CUDAHY, WIS., U. S. A., A SUBURB OF MILWAUKEE

The Worthington Pump and Machinery Company was incorporated in 1916 and took over all of the subsidiary companies owned by the International Steam Pump Company, including Cudahy's Power and Mining Machinery Company and International Gas Engine Company. By May 1924, the company ceased operations in Cudahy, and the 28-acre property was left vacant for four years until it was sold to the George Meyer Manufacturing Company.

Three

A NEW CITY BOOMS WITH BUSINESS

Dretzka's Dry Goods was established in 1901 by Frank and Emelie Dretzka, who had emigrated from Germany in 1889. Frank worked at Cudahy Brothers and as the school janitor while Emelie managed the store. By 1909, the little store's business had outgrown its space, and the first unit of the present store was built. Through the years, additions were made to the building until it grew into a three-floor department store widely known for its high-quality fashions and merchandise. Ownership of the store passed to succeeding generations of the Dretzka family after Frank's death in 1932, with the fourth generation of Dretzkas currently operating it. Members of the Dretzka family were active in civic affairs and also operated a furniture store, food market, insurance agency, and real estate office.

Dr. Bernard Krueger established his medical practice in Cudahy in May 1905. A graduate of the Wisconsin College of Physicians and Surgeons, Dr. Krueger was Cudahy's first school physician. He also served as the plant physician for Cudahy Brothers Company in 1907 and 1908 and as the city's health commissioner from 1914 to 1916. His home and office building on Layton Avenue was purchased by Dr. Edward Tomasik in 1951.

Christ Woehsner opened Plankinton Hall in 1905. This entertainment destination included a dance hall, a billiards room, a bowling alley, and an amusement room with a stage. Woehsner sold the business in 1913, and it has passed through many owners since then. Pictured in 1928 are owner Paul Csepella, painter Ed Magyera, and barbers Louis Csepella and Frank Hilety, along with other workers renovating the building.

Joseph Wojtysiak built this hall in 1905 for hosting wedding receptions, plays, parties, and even roller skating events. The business fell on hard times during Prohibition, and Wojtysiak sold it to Stanley and Stella Glowacki in 1927. Renamed Pulaski Inn, it remained in the Glowacki family until 1998, when Brian and Karen Swessel purchased it. They operate Pulaski Inn as a banquet hall and catering facility.

Otto and Bertha Frank moved to Cudahy in 1906, opening a drugstore that also housed the first public library in Cudahy in the back of the store. In 1913, Frank erected a new store and living quarters on the busy corner of Packard and Barnard Avenues. He remained at that location until 1983, when it became the Cudahy Pharmacy. Today, the building houses Labor Ready.

This 1906 photograph shows the interior of the Cudahy Fuel Company office. Christ and Alma Becker owned and operated the business; Alma often brought their children to the office so she could keep the books and wait on customers. The company sold coal, wood, and building materials, then later offered fuel oil and HVAC equipment. The business remained in the family until it was sold in 1969.

The *Cudahy Enterprise* newspaper was started by Thomas and Sheridan McElroy, a father and son who moved to Cudahy in 1907 after working at various newspapers throughout the Midwest. The first issue was published on October 17, 1908. The weekly paper continued until 1951, when it was purchased by Leo Stonek and merged with the *Cudahy Reminder-Regional Press* to become the *Cudahy Reminder-Enterprise*.

George Ponto is shown behind the counter at the Coliseum Electric Theater. George and his brother Arthur opened what was Cudahy's first motion picture theater in 1908. Shows cost a nickel each, and there was an ice-cream parlor in the lobby. During daytime hours, the theater served as a shooting gallery. The Pontos operated the theater until 1910, when Jacob Disch took it over.

The Coliseum Theater was a venue for more than just motion pictures: traveling lecturers, performers, and vaudeville shows were also regularly featured. This crowd has gathered to see Caribou Bill and his dog sled team, who had traveled to Cudahy from Alaska as part of their planned trip around the world.

This 1921 photograph shows a group of students waiting to make their monthly deposits at the Cudahy State Bank. "School Banking Days" were offered by the bank as a way to instill good habits of thrift in the children. It must have worked, because by July 1 of that same year, 558 children had deposited $7,110, or about $12.78 per child. The bank was the first in Cudahy.

Emil Huebner started the Huebner Dairy on Layton Avenue in 1910. After his death in 1937, sons Victor (pictured) and Richard took over the business. At its peak, the dairy delivered milk to 2,400 customers, completing the daily rounds by 6:00 a.m. Before refrigeration, the milk was kept cool with 100-pound blocks of ice harvested from Lake Michigan. The Huebner family remained in the dairy business for over 60 years.

Edward Magyera was born in Budapest, Hungary, and educated as an artist and painter. After immigrating to Cudahy in 1908, he opened Magyera's Paint and Hardware Store in the former Cudahy State Bank building. Edward and his wife, Anna, operated the store until 1949, when their son Arthur took over until his death in 1978. In 1980, the building was completely remodeled for the Greek Islands Restaurant.

Peter Van Eimeren and Christine Puetz were married in 1896. They worked and lived for many years on farmland bordering the city of Cudahy. In 1911, the family moved to town and took over the Hotel Windsor, a saloon and rooming house on the corner of Packard and Layton Avenues run by John Kiphutt. Peter is pictured outside the hotel in 1913, less than a year before he died unexpectedly.

Would you deal with a house that is square,
That handles Hardware that will wear,
That holds all the trade It ever has made?
THIS HOUSE has that record so rare.
IF YOU want any tool, want it Quick,
Any tool from a Penknife to a pick,
A Hod for the Mortar, A Pail for the water,
Or a Trowel for laying the brick.

A Hammer to drive in the tacks,
A Saw, a Hatchet or Axe,
A Shovel, Brace, Spade,
Any Tool that is made—
We are giving you only the facts
When we say that this Tool you will find
In the Store that is never behind,
That is second to none,
That is A Number One—
Just fix this idea in your mind.

HENRY VOGL
GENERAL HARDWARE and TINNING
810 PACKARD AVE.
Phone Cudahy 73-X CUDAHY, WIS.

It will pay you to Visit Our Store

Henry Vogl, Cudahy's first baker, sold his bakery at the corner of Packard and Barnard Avenues to his uncle Jacob Spies in 1910. The following year, he built a new store and started a hardware business, which he sold in 1912 to Paul Strehlow of Bay View. In 1913, he purchased the Milwaukee Pretzel Company. Pictured here is the front of a sewing kit given to customers as a promotion.

58

This photograph shows the Majestic Theater shortly after it opened on November 16, 1912. Owned and operated by Jacob Disch, the theater featured a variety of entertainments ranging from movies to live action shows. With 375 "unusually large" seats, a sloping floor, and five emergency exits, it was on par with show houses in much larger cities and attracted crowds of all ages.

George Nelson is shown assisting Frank Chovanec in his ice-cream parlor. The parlor was a popular gathering place from 1913 until Nelson's death in 1970. In the mid-1950s, the walnut booths in the back of the shop were sealed off so that Mueller's, the bakery next door, could expand. In addition to ice cream and other refreshments, customers could also purchase small gifts and toiletries.

The Cudahy Lumber Company was built in 1914 at a cost of $25,000. Herman Radeske purchased it in 1922 and put nephew Edwin Budzien in charge. Budzien grew the business by adding building supplies to the inventory. His slogan, "Let Us Board U," was on the company's truck, seen here decorated for a parade in 1938. Budzien purchased the yard in 1965 and sold it in 1983 at the age of 86.

Pharmacist Alois Detlaff came to Cudahy in 1917 and established Detlaff's Drug Store across from Washington School. In 1921, he moved to the corner of Packard and Layton Avenues, where he remained until the business closed in 1942. In addition to prescriptions and sundries, the store had an ice-cream parlor. Pharmacist Edward Nicgorski is pictured with his future wife, Sylvia Spielbauer, outside the store.

Stephen and Louise Brauer opened this small grocery store on Layton Avenue in 1920. By the mid-1920s, they had converted the store into a "soft drink" parlor and billiard hall. After Prohibition ended in 1933, it became known as the Brauer Tavern. Brauer remained behind the bar until the mid-1950s, when he brought in a partner, Phillip Lorum, who took it over after Brauer retired.

Born in Poland, Frank Sztukowski immigrated to the United States at age 19 in 1903. He opened a small tavern on Lake Drive called the Lakeview Inn in 1911. Nine years later, in 1920, Sztukowski built the new Sheridan Hotel and Palm Gardens Tavern on the site, shown in this 1924 photograph. The hotel was a showplace, featuring stained-glass windows, terrazzo floors, and a mahogany bar. Frank's wife, Cecelia, managed the restaurant, while Frank oversaw the tavern and the hotel. After Cecelia died in 1953, the restaurant was closed, and when Frank died in 1955, sons Stanley and Norbert took over. In 1968, the newly remodeled Fountain Blue restaurant opened, serving many of Cecelia's original recipes. The restaurant remained in the family until it closed in 1998. (Above, courtesy of the Archives Department, University of Wisconsin–Milwaukee Libraries.)

Paul Meszaros opened the White Front Tavern on Packard Avenue in 1921, after purchasing the property from Milwaukee Brewing Company. Prior to opening the tavern, Meszaros and his wife, Julia, had owned a grocery store. In the late 1920s, Meszaros left the tavern business, and a few years later, Paul Brinza purchased the building, operating a tavern there for many years. It currently is home to Reggie and Gerry's.

Joseph Romanowski worked as a laborer and a saloonkeeper in Cudahy before starting Romanowski Coal Company, supplying coal, fuel oil, and wood. His oldest son, Roman, worked with his father until Joseph's death in 1942, then took over the family business. This pre-1950 photograph shows one of the delivery trucks being serviced, probably at the coal yard on Morris Avenue. The office was located on Packard Avenue.

The Buschauer Grocery on Packard Avenue was one of the city's 33 neighborhood grocery stores in 1921. Louis and Margaret Buschauer, immigrants from Hungary and Romania, operated the store until 1933, the year this photograph was taken. Many of the canned goods for purchase in the store were provided by Roundy's, a company still in existence today.

Frank Malovec opened his tavern in 1922 after purchasing the business from Frank Falkowski. The building was erected in 1904 and featured the tavern on the first floor with living quarters above. A World War I veteran, Malovec was active in the American Legion, and Legion members would often meet at Malovec's Tap after marching in Cudahy's parades. Following Malovec's death in 1948, the family sold the tavern in 1953.

Cudahy's first undertaker, John W. Strandt, finally had some local competition when Frank M. Konwinski established his funeral home in 1923. A member of the Polish National Alliance, Konwinski served on Cudahy's Park Board from 1931 to 1940 and on the fire and police commission from 1939 to 1944. When he retired in 1952, his lavish establishment on Underwood Avenue was purchased by Henry Ryczek of Milwaukee.

Phone Cudahy 290

Frank M. Konwinski

Undertaker
and
Licensed Embalmer

500 UNDERWOOD AVE. COR SWIFT CUDAHY, WIS.

Housing was in short supply in early Cudahy, and many employees lived in Milwaukee and commuted. At 25¢ per ride, steam train service was expensive, so Patrick Cudahy lobbied for an interurban electric rail line to ferry workers from Milwaukee to Cudahy. The Cudahy Special, also known as the "Scoot," was established in the early 1900s and is pictured in this 1923 cartoon from the Cudahy Brothers Company newsletter.

65

Frank Sztukowski and John Staszak opened S & S Paper Products, manufacturers of milk bottle caps, on Lake Drive in 1924. Frank served as president and treasurer, while John was the vice president and secretary. After John left the business, Frank's son Stanley took over as foreman. In 1933, Frank purchased the former Federal Rubber office building on Layton Avenue and moved the business there a few years later. He sold the Lake Drive factory to Lucas Milhaupt in 1945. After Frank's death in 1955, the business was closed until 1958, when Stanley reopened S & S Paper Products as a die-cutting and print shop. The company closed in the late 1960s. The Sztukowski family also owned the Sheridan Hotel, a tavern on Pulaski Avenue, and a realty business in Cudahy. (Above, courtesy of the Archives Department, University of Wisconsin–Milwaukee Libraries.)

Venus and Werkowski Motors, a Studebaker dealership, was founded by Carl Venus and brother-in-law Eugene Werkowski in 1924. Venus Motors began selling Fords in 1939, several years after Eugene left the business. Active in civic affairs, Carl was known for his community support. Carl's sons Ralph and Don took over the dealership following his death in 1965, and in 1985, they sold it to Ed Witt.

Morris Wagan, a master tailor, emigrated from Poland in 1921 at age 24. In 1924, he opened a tailor shop and shoe store on Packard Avenue. Wagan quickly expanded into menswear, and the business flourished, featuring high-end merchandise and personal service. Sons Harry and Isadore purchased the business from their father in 1945, and it remained in the family until 1980.

The Cudahy Bowling Center was operated by three generations of the Furdek family. John Furdek built the six-lane bowling alley in 1924. After his death in 1928, the business changed hands seven times before his sons purchased the lanes in 1954. Chic, the silent partner, and Joe, the manager, mortgaged their homes to reclaim their father's bowling facility, which now had 16 lanes. Members of both families worked hard to renovate and upgrade the business over a span of 52 years. Carey and Jeanne Catania purchased the bowling alley in 2006 and changed its name to Motion Plus Lanes. In addition to their leagues and junior bowling program, the Catanias run charity events at the lanes. Motion Plus Lanes is one of the largest contributors to the Toys for Tots program in Milwaukee County.

In 1925, Anton and Mary Adamczyk purchased a neighborhood grocery store and added a butcher counter. Just 13 years later, Anton died, leaving Mary with six children. The whole family helped run Adamczyk Foods, until son Eddie eventually took over. Renowned for their homemade sausages, Eddie (pictured) and wife Birdie, along with son Dennis, continued the business. After Eddie died in 2010, Dennis continued the business until he retired in 2015.

In 1926, Kurt Dahm moved to Cudahy, opening the Badger Paint store on Barnard Avenue the following year. He retired in 1965, turning the business over to his son, who ran it as an affiliate of the Ace Hardware chain for the next 31 years. Dr. James Bykowski purchased the building in the fall of 2002, remodeling it for his chiropractic offices.

John Milewski operated Milewski's Bowling Arcade, featuring five lanes and a storefront, on Pulaski Avenue from 1926 to 1929. Following a series of short-lived bowling alleys, the Polish Legion of American Veterans (PLAV) Walter Muszynski Post No. 26 purchased the building in 1958, offering bingo and bowling for 40 years. The PLAV sold the building to the Serenity Club in 1998. (Courtesy of the Archives Department, University of Wisconsin–Milwaukee Libraries.)

In 1914, Patrick Cudahy hired George Scott, an experienced gardener trained in England, to run his Cudahy Floral Company. By 1926, Scott had purchased the company from Cudahy and had built a second greenhouse. A 1936 hailstorm demolished the original greenhouse, breaking 150,000 square feet of glass and destroying most of the plants. It was not rebuilt. Family members continued to operate Scott's Rose Gardens until 1983.

Built in 1926, this building on Pulaski Avenue included seven apartments and two storefronts on street level. At the time of the photograph, it housed Valerian Popowski's real estate and insurance office, Dr. Ambrose Maciejewski's medical office, and Cudahy Savings and Loan. In later years, the building was the first site of Gora's Pharmacy, an appliance store, and several beauty salons. (Courtesy of the Archives Department, University of Wisconsin–Milwaukee Libraries.)

People's State Bank was built in 1926 on the former site of the Evangelical Christus Church. The bank was the target of two armed robberies, in 1929 and 1931. After People's State Bank closed, Cudahy State Bank took over the accounts in 1931, and the building was used as a meeting space for the Knights of Pythias until the American Legion Kerlin Farina Post 16 purchased it in 1944. The Legion post, shown above in 1961, occupied the space for over 30 years. In 1977, the Patrick Cudahy Employees Credit Union moved in after an extensive restoration project to return the bank to its original 1920s decor. Two years later, it was renamed Peoples Credit Union. In 2011, Peoples Credit Union merged with Landmark Credit Union, which retains the bank's original vault as well as many other original architectural features.

Michael Pinter owned and operated Pinter's Inn, opened on Barnard Avenue in 1927. In 1934, Pinter remodeled the former electrical store to look like an English pub. When he retired in 1962, his son Michael Jr. took over the tavern. Pictured here in the late 1970s are, from left to right, Gerald Houlehen, Schlitz Beer chairman Daniel McKeithan, Mike Pinter, and Schlitz Beer president Frank Sellinger.

George J. Meyer Manufacturing Company was established in 1904 and moved to Cudahy in 1928. Manufacturers of bottle-washing equipment, the company later expanded its product line to bottling equipment. By 1939, approximately 62 percent of all US breweries used Meyer's Dumore-brand machines. At the company's peak in the mid-1950s, it employed over 1,500. Following an economic downturn in the early 1980s, the Cudahy plant closed in 1985.

Clara Fiedler (standing at the door) and her husband, Arnold (in front of the mirror), operated the Doris Mae Beauty Shop for 22 years. The salon, named after their daughter, opened on Barnard Avenue in 1929 and moved to Layton Avenue in 1934. At the new location, customers were treated to a demonstration of the latest techniques in permanent wave winding.

Four
BUSINESS CHALLENGES IN DEPRESSION AND WAR

Charles Tuma immigrated to Cudahy from Czechoslovakia in 1929 and started his own tailoring business on Munkwitz Avenue. Taken outside the shop, this 1932 photograph shows his neighbors and fellow Slovaks Marie and Mike Devecka. In 1937, Charles's wife, Anna, and son Lubo joined him in Cudahy. Charles continued to work as a tailor until the late 1960s.

The F.W. Woolworth store opened in 1931 in downtown Cudahy. The Dretzka family was operating a variety store on the property, but after Woolworth's expressed an interest, the family moved the existing building and then erected a new store for Woolworth's. In 1955, the Dretzkas purchased and razed the building to the south, doubling the space for an expansion. Woolworth's closed in 1975.

Joe Ratka (right) and his friend are shown leaving Andrew Firer's Tavern on Squire Avenue. Firer was known for operating saloons in Cudahy; this one was open from 1932 to 1945. The building had housed the original Dretzka and Sons Department store. Firer died in July 1950 after being struck by a North Western Railway switch engine.

William M. Quirk founded the Quirk Bottle Case Works in Milwaukee in 1919. Manufacturers of milk crates and later refrigerated cabinets, the company moved to Cudahy in 1932 and was renamed the Quirk Co. William retired in 1948, and his sons expanded the company into a number of other areas, including real estate, prefabricated homes, and equipment leasing. By the 1980s, all of the divisions had been sold or closed.

Established by the Nissen family in 1932, Milwaukee Crane and Service Company manufactured traveling overhead cranes. The family owned the company until 1956, when it was purchased by Industrial Enterprises of New York. The following year, Milwaukee Crane won a government contract for a 500-ton crane, one of the largest ever to be built in the United States. The company was sold to Harnischfeger in 1964 after suffering substantial losses.

The oldest of seven children, Joseph Salvatore became the head of his family as a teenager after both of his parents died at a young age. He spent several years traveling on the vaudeville circuit with partner Charles Becker as a trick roller skating act, then opened a shoe-shine parlor in the mid-1920s. By 1934, he built Sullivan's Cigar Store, named after his baseball nickname: Sully. The following year, Joseph married Mary Luljak. The two operated the shop together for over 60 years and lived in an apartment above the store. Offering shoe shining, hat blocking, cigars and tobacco products, snacks, and newspapers, the store was a Cudahy institution for generations. After Joseph died in 1995, Mary kept the shop open until her death in 2011.

Workers at Modern Machine Works manufacture precision crankshafts in this 1940s photograph taken in the machine shop. Established in Milwaukee in 1924, the company moved to Cudahy in 1934. Business boomed during World War II, but the company struggled as demand dropped off after the war. A mid-1960s modernization program returned the company to profitability. In 1999, Modern Machine Works closed its Cudahy facility, consolidating operations in South Carolina.

Ella "Lenie" Ponto worked for a few years at the William Ollman Bakery before taking it over in December 1936. She renamed Shirley's Pastry Shop in honor of her daughter. Lenie's husband, George (pictured) also helped out in the shop. In the early 1940s, Lenie sold the business, but the shop remained open under various proprietors until 1948.

Dr. Eugene Ackerman moved to Cudahy in 1937 and started his medical practice. A physician and surgeon, he was instrumental in getting penicillin for civilians during World War II. In 1948, he founded the Ackerman Clinic and worked with his younger brother Dr. Donald Ackerman and dentist Dr. Harry Friedman. Eugene was one of the founding doctors at Trinity Hospital. He practiced medicine in Cudahy until his death in 2000.

Clarence "Sid" Ollmann and his wife, Mary (pictured), opened the Council Tavern in the Kleineider building on the northeast corner of Layton and Packard Avenues after they were married in 1940. The young couple operated the tavern for about 15 years. After the Council Tavern closed, Jo-Al Tap and, later, the Little Tiger Tavern occupied the space. The building was razed in December 1976.

Roy and Loretta Behlendorf started their floral business at Packard and Layton Avenues in 1941. A decade later, this shop was built a few doors down the block. A lifelong employee, Marilyn Kasmierzke, purchased the business after Roy's death in 1994. She sold the building in 2001 to Peter Azzarello for his business, the Lakeshore Tax Corporation.

In 1941, Standard Oil built a service station at the busy corner of Packard and Plankinton Avenues. Through the years, it was operated by a number of different owners, including Robert Dunford, Edward Kuehn, Ken Brahm, and Orville Hoffman. Ervin Iwinski took over in the mid-1960s and operated Erv's Standard Service until he retired in 1991. This photograph shows Brahm's Service Station in 1961.

Paul Valuch became a master plumber in 1936 and opened Valuch Plumbing and Hardware Company in 1941. Valuch (left) and his brother-in-law Ervin Behmke are shown inside the store in 1965. Behmke managed the hardware store until it closed in 1964 and then continued to manage the ensuing plumbing supply business. Valuch retired as a plumbing contractor in 1982.

A visit from Santa Claus was celebrated annually at Valuch Plumbing from 1951 to 1962. Paul Valuch's brother-in-law Louis Studer played the part of Santa. He would visit with children one Saturday early in December, giving them each a small box of candy and a piece of fruit. To advertise the upcoming visit, Santa traveled the streets of Cudahy on the Valuch truck, complete with signs and Christmas music.

Employees of the Cudahy Tanning Company are shown drying full grain side leather on a vacuum dryer in the Packard Avenue plant. William B. Law purchased the Scherer Leather Company in 1942 and, with his son William L., manufactured fine leather for footwear, baseball gloves, belts, handbags, and luggage. Cudahy Tanning closed in 2009 after the firm agreed to merge with Prime Tanning of Berwick, Maine.

Donald Lucas and Howard Milhaupt left Ladish in 1942 and established Lucas Milhaupt, a cutting tool manufacturing shop. After moving to Cudahy in 1945, brazing preforms for joining metals were added. By 1963, growth necessitated this facility on Pennsylvania Avenue; today, the company has expanded into North America, Europe, and Asia. It is a global supplier of brazing and soldering materials for the electronic, construction, transportation, and mining markets.

Founded by Victor Grant in 1942, United Welding and Manufacturing Company Inc. specializes in steel fabrication and welding services. Grant was active in civic affairs, especially the drive to build a hospital in Cudahy. He donated 11 acres of land for the hospital, used United Welding cranes to clear the trees from it, and served on the hospital board of directors for many years. After Victor died in 1978, his son Gerald took over the company. Under his leadership, United Welding achieved ISO 9001:2008 certification in 2013. Todd Grant, Gerald's son, currently serves as the vice president and is the family's third generation in the business. These photographs show the company as it looked in 1962 (above) and a current employee grinding part of a truck frame for a local manufacturer (right).

Joseph Schandl took over the Packard Avenue Garage from Frank Spies in the early 1940s. The Schandl Motor Company was a Hudson car dealer that also offered service, repair, and gasoline. Taken February 1, 1947, this image shows the aftermath of a record-breaking blizzard that paralyzed the city for several days.

Jasper and his wife, Josephine Vaccaro, operated the Four J's Bar on Packard Avenue from 1944 until 1972. The building had been erected by Dr. Benjamin Palmer in 1919 for a residence and office. After the tavern closed, the other two J's—Jack and his sister Jacquelyn—remodeled the downstairs into a beauty salon. Jack and his wife, Sharon, refurbished the upper flat in 1992 for their new retirement home.

Cudahy Savings and Loan moved to its fourth location on the northwest corner of Packard and Layton Avenues in 1944. Formerly the First Slovak National Building and Loan Association, the fraternal institution was chartered in 1912 and met weekly at Vrana's Hall. One of the founders, Joseph Kurtin, served as president for 38 years. His successor, Frank Henika, had the building demolished in 1976 to make room for the fifth facility.

Joseph and Elaine Wasicka owned the National Photo Supply on Packard Avenue for over 30 years, occupying the former *Cudahy Enterprise* offices in the mid-1940s. Joseph also collected antique cameras, which he displayed in the back of his store. In 1964, he opened the World Camera Museum in Baraboo, Wisconsin, to showcase his extensive collection. After Joseph retired in 1975, National Photo remained open under new ownership until 1988.

On April 27, 1945, a group of 15 Cudahy Brothers Company employees formed the Cudahy Consumers Cooperative and took over the operation of the Cudahy Brothers Commissary on July 1. By the end of that year, the co-op's sales of $132,000 amounted to $10,628 in patronage refunds to its members and users. The co-op purchased and remodeled Edward Petri's store on the corner of Packard and Squire Avenues in 1946. It also purchased the Kurtin Brothers Fuel Company for a coal yard and partnered with Lang's Service Station to offer gasoline cards. On January 20, 1947, a line of customers waited in the cold for the store's grand opening. Delia Bartholemew (below, left) was the first customer, assisted by cashiers Helen Maygel and Eleanor De Grace. The co-op was in business for 12 years; Albert Dretzka purchased the property in 1958.

Florence Pelosi and Hubert "Hub" Dretzka are shown in the office of the Hub Dretzka Insurance Agency in this 1960s photograph. Dretzka established the business in 1945, after having worked for several years in his father's realty business. The agency's slogan, "rest assured with the best insured," served Dretzka well until his retirement in 1995. He was active in a variety of civic and community organizations throughout his career.

Milton "Bud" Schmidt owned Bud's Sport Shop on Packard Avenue from 1946 until 1958. This second location, next to Wagan's store of fine men's apparel, was expanded in 1954 with a second-floor addition. Six years later, the building was sold to Collage Furniture, and Schmidt built three A&W Drive-Ins. In 1963, he founded the First National Bank of Cudahy and served as the first chairman of the board.

In June 1946, Joseph Clark opened the Dutchland Dairy on Packard Avenue. The store was one of 15 in the Milwaukee-based chain and was "more than a dairy," as its song proclaimed. It was a bakery, delicatessen, restaurant, and ice cream store. The building was enlarged and remodeled six times during the business's 31 years of operation. It currently houses Gard N Angel Child Care.

From 1947 to 1961, residents could purchase Hot Point appliances or hire an electrician from R.J. Coconate Electric. Rocco Coconate and his wife, Louise, started their business on Layton Avenue before moving to today's Medivan building. For their third expansion, they moved to South Milwaukee, where the family still operates an electrical contracting firm.

Mayor Joseph Wagner's home at Cudahy and Packard Avenues was purchased by doctors Jacob Fine and David Lando in 1948 for their Fine-Lando Clinic. The 1907 building was renovated in 1959 with a large addition. After the clinic moved to Ramsey Avenue in 1969, the building was used by Bloomfield Realty, Lubbert Investment, Medivan, and Michael Lux before being purchased by Robert and Patricia Jursik in 1999.

LaVerne "Toots" Schooley (third from left) and her husband, Ira "Rusty" Schooley (fourth from left), are shown in the late 1940s. Daughter LaVerne is also pictured at far left. Rusty's Bar and Tavern was opened shortly after the end of Prohibition and remained a popular gathering place through 1971. The bar included two duckpin bowling alleys in the basement and offered men's and women's leagues.

Christ Mueller established a bakery from his home on Squire Avenue in 1927, with help from sons Arthur, Emil, and Christ. In 1949, Emil and wife Olga established Mueller's Bakery and Delicatessen on Packard Avenue, next door to Nelson's Ice Cream Parlor. Emil retired at age 70 on December 24, 1971, and tragically died from a heart attack later that night. The building was razed the following year.

Five
BUSINESSES PROSPER IN POSTWAR ECONOMY

James Chetti opened Jim's Texaco station on Kinnickinnic Avenue in 1950. In 1954, brothers Joseph and Jack Oliva purchased the franchise, which they operated jointly until the late 1950s. This 1966 photograph shows Joseph Oliva standing proudly outside his station. The neighboring Kohl's grocery store purchased the property in 1970, and the station was subsequently razed.

Walter Ollmann opened the Cudahy News and Hobby Center in September 1949. In 1952, he took over the operation of Cudahy Liquor next door. Ollmann eventually moved the hobby center into the liquor store building on Packard. Walter's wife, Marie, helped with the business until his death in 1960. Richard Prokop became the new owner of both stores, and in 1965, he sold the businesses to another couple, the Gordons. Gordon and Ann Gordon eliminated liquor and concentrated on expanding hobby goods. Their sons Jay and Gary took ownership in 1981, and in 1983, Jay and his wife, Kristine, purchased the dime store building across the street. The Gordons created a destination retail business, one of the best hobby stores in Milwaukee County. Jay and Kristine purchased a store in Greenfield in 1998 and closed the Cudahy location in 2002.

Josephine Puetz opened Country Flower Shop in 1950, operating the store for 31 years before sons John and Robert took over. After Robert retired in 2013, manager Paul Veres assumed ownership of the shop. Country Flower Shop is the oldest existing flower shop in Cudahy, and is located on land that was originally purchased by the Puetz family in 1845.

Albin Brykczynski quit his job at the Cudahy Fire Department to help his wife fulfill her dream of owning a candy store. Mary "Mae" Brykczynski operated her confectionery on Packard Avenue from 1950 until 1961. After Mae retired, five businesses came and went before Dr. James Bykowski purchased the property in 1981. His office was at this location for 20 years.

95

Halvor and Martha Jacobson purchased this tourist inn from Thomas and Nina Hart right after the property became part of Cudahy in the 1950 Silverdale annexation. Located on the bluffs of Lake Michigan near Grant Park, the Hart House was renamed Cliff House. The inn was open for business from 1951 to 1955. Years later, the building was razed for the Lake Shore Tower apartment project.

A fixture on Cudahy's tavern scene, Mary Vnuk served drinks to many local factory workers at Vnuk's Tavern from 1951 to 1996. Mary and husband John purchased the 1910 tavern and rooming house as an investment shortly before he passed away. After Mary retired, her grandson David took over. He expanded the property in 2002, adding a stage for live bands. The building is currently home to the Metal Grill.

From 1951 until 1961, there was a Crown Cork and Seal warehouse on Packard Avenue. The parent company started in Baltimore in 1892, when William Painter invented the "crown cork," or bottle cap. The new industry became a worldwide leader in packaging technology for beverage and food, personal care, and household products.

Located near the south entrance to the Cudahy Brothers stockyards, Red's Service Station was frequented by workers at the plant as well as the truckers transporting livestock. Edward "Red" Hoyberg served as the station manager after coming to Cudahy in 1951. Born in Iowa, Red moved to Texas before enlisting in the Army during World War II.

Henry Ryczek worked with his father, Leo, and brothers at Ryczek and Sons in Milwaukee for 18 years before he purchased Konwinski's funeral parlor in Cudahy in 1952. Eleven years later, Ryczek hired Milwaukee architect Myles Belongia to remodel and expand the building. Henry and his wife, Irene, leased the property in 1978 to the Independent Mortuary Corporation, which became the owner in 1986.

Tom Carvel began selling ice cream out East in 1934 and started franchising Carvel Dairy Freeze stores in 1949. Cudahy's store was built in 1955 on Packard Avenue. A dispute about purchasing products only from Carvel erupted in the early 1960s, which led to the closing of many of the chains. Boy Blue Stores leased the property in 1967, followed by Cudahy Dairy Treats. The building was razed in 1987.

William Fischer built this small barbershop on Packard Avenue in 1910, directly in front of his home erected the year before. Fischer worked as a barber for more than 30 years before he sold to Red's Barber Shop. In the mid-1950s, Glen Proeber bought the business and worked as a barber for the next 44 years. Active in community affairs, Proeber also served as an alderman for 20 years.

Gerald and Vera Brophey opened their Shamrock Diner in 1956, returning the building to its original use. Casimir Lesinski opened the building's first lunch counter in 1928, but by the Depression, he was renting out the space as a dry goods store. After the Bropheys closed their business in 1961, D & G Lunch, Johnny's Lunch, and Parker's Lunch all followed at this location. Currently, it is home to Fili's Café.

Jack DeSalvo's Restaurant and Lounge was downtown Cudahy's fine dining establishment from 1956 until 1994. Prior to DeSalvo's, Jack and Marie operated the tavern Jack's or Better. After her father's death in 1985, daughter Toni DeSalvo ran the family business for nine years. The building was razed in December 1999.

After living in South Milwaukee for many years, Albert and Ann Slaaen moved to Cudahy in the early 1940s. Albert was a foreman at Bucyrus-Erie, but in 1956, he built the Alana Motel on Packard Avenue on land adjacent to his home. He operated the motel until his death in 1975. The following year, an Arthur Treacher's Fish & Chips fast-food restaurant opened on the site of the motel.

Milwaukee Cylinder on Pennsylvania Avenue was established in 1956 by Darold Skelton, and has always been known for its made-to-order cylinders used in hydraulic and pneumatic applications. The unofficial company motto, "specials are standard at Milwaukee Cylinder," reflects the commitment to accept the difficult but financially rewarding contracts. This bird's-eye view photograph shows the highly organized, orderly plant floor.

When Packard Plaza opened in May 1956, it was considered one of the finest shopping malls in Milwaukee County, and was the first to serve the southern suburbs. Major retailers like Sears, J.C. Penney, and Gimbels-Schuster's were at the mall through the years. During the 1980s, the economy slowed, and many retailers moved out. In the early 1990s, major renovations were undertaken to modernize the mall.

Robert Totushek is pictured in his Packard Plaza Barber Shop. He started out in his father's shop before opening his own on February 1, 1957. In 1959, Totushek moved the shop to its present location, and the business grew to support a staff of five during the week and six on Saturdays. Totushek retired after more than 50 years as a barber, and longtime employee Michael Helgeson took over.

After serving in the Korean War, Walter Grebe joined his mother's Milwaukee bakery business. He opened his first Grebe's Bakery on Barnard Avenue, and in 1957, he moved the shop to the Glazier building on Packard Avenue. He also purchased a plant in West Allis that became the home of the nationally successful Grebe's Bakeries Inc. The Cudahy location remained open until 1980. The historic building was destroyed by fire in 2004.

Joe's K Ranch was established in 1958 by Joseph Kotarak, pictured here tending bar in 1981. After he retired in 1993, Joe's son Jerry and his wife, Marilyn, took over. Jerry expanded the tavern to include a restaurant, two banquet rooms, volleyball and horseshoe courts, and a beer garden. It serves as a meeting place for many local organizations.

Born in Czechoslovakia, Frank Chovanec came to Cudahy in 1932. After serving in World War II, he worked at Ladish, then purchased Joe's Roundup Inn in 1958. In 1961, a fire caused extensive damage to the tavern. After renovations were complete, Chovanec and wife Betty reopened it as the Galaxie Lounge. He sold the lounge a few years later and became an insurance agent as well as a Cudahy alderman.

Founded in Milwaukee in 1935, Bostrom Manufacturing Company moved its metalworking department into an empty factory in Cudahy in 1958. As business steadily grew, the company enlarged the original 1919 building, more than tripling the space in just 15 years. By the early 1980s, business had slowed, and the Cudahy plant was closed in 1989. During its heyday, Bostrom was the largest US supplier of suspension seats for heavy trucks.

Cudahy was home to a go-kart track on the west side of the city, operated by Frank and Olga Wederath from 1959 to 1963. This November 1961 photograph shows the track, judging tower, and the Karters Kitchen, which housed concessions and restrooms. A complementary business, Cudahy Kart Sales, was operated on Layton Avenue by partners Ray Winkler, Tom Armstrong, and Darold Skelton, but both businesses were short-lived.

On a typical day, employees of the Porkie Company of Wisconsin Inc. process 22,000 bags of pork rinds. Roman Rydeski bought the company in 1948 and relocated to Cudahy 10 years later after purchasing the former Cudlak Food building. Today, Roman's son and grandson, Richard and Tom Rydeski, operate the business. Their pork snacks and pickled items are sold nationwide.

Tom Rydeski holds a bag of pork rinds produced at the Porkie Company. The company also produces bacon puffs, pork curls, pork cracklings, turkey gizzards, pickled eggs, pickled sausage, pickled pork hocks, pickled pigs' feet, olives, nuts, and creatos (pickled skins). The Porkie Company uses Patrick Cudahy brand lard in its fryers and is known for its high-quality production methods.

Cudahy State Bank, Cudahy's first bank, changed its name in 1959 when the institution joined the Marine Corporation. Corporate vice president and bank chairman C. Harold Nicolaus was the son of founder Charles Nicolaus. Charles and David Rosenheimer started the bank in 1909 with $25,000. Nicolaus moved the business in 1920 to the city's busiest intersection. His son put two additions on the Neoclassical building designed by Leigh Hunt.

John W. Gargulak founded Midwest Millwork in 1960. Located next to the Cudahy Lumber Company, the store sold a variety of building supplies and made cabinets and stairs. In 1983, the family business was expanded when Gargulak purchased the lumberyard. Sons John and Martin worked for their father. John sold the company to Bliffert Lumber and Fuel Company in 2015.

When Sol Steren opened Cudahy's first McDonald's in Packard Plaza in 1960, the hamburgers cost just 15¢. It was only the third McDonald's in the area and quickly became a popular destination. Through the years, Sol opened six more restaurants throughout southeastern Wisconsin. In 1971, the restaurant was remodeled and a grand reopening celebration was held, with Ronald McDonald arriving by helicopter. Sol and his wife, Rose, were steadfast community supporters, especially of programs benefitting youth. They were instrumental in helping build the Ronald McDonald House in Wauwatosa in 1984. In 1995, McDonald's moved to its current location on Packard Avenue. Sol's oldest son, Jeff, joined his father in the business, and today, he operates 12 McDonald's restaurants. Jeff and his wife, Jody, continue the legacy of community involvement and are great supporters of area youth, local organizations, and libraries.

Dominic Gardetto opened Mr. G, a TV and audio sales and service shop, on Packard Avenue in the early 1960s. This 1965 photograph shows the shop shortly after Gardetto moved it to a larger building on Layton Avenue. Dominic and his sons James and Robert operated the shop until Dominic's death in 1998. The store closed the following year.

Arthur Skwor stands behind the cash register at Plaza Beer and Liquor in this photograph, taken shortly after he purchased the business in 1963. When Frank Peterson first opened the store in 1956 in Packard Plaza, it offered delicatessen items, milk, beer, and liquor. Arthur and his wife, Arlene, streamlined the merchandise and operated the store until 1997. They were known for their quality customer service and community involvement.

American Welding and Engineering Company moved to Cudahy from Milwaukee in 1965, needing room for expansion. Specializing in metal fabrication, the company made tanks, bins, hoppers, and loading dock bridges, which were marketed under the Rite-Hite brand name. In later years, the firm focused mainly on heavy manufacturers in the mining and railroad industries. By 2012, the company was in financial trouble. It was dissolved two years later.

In 1966, Henry Herdeman and Walter Klug purchased the former Mel's Service Garage building and opened the Herdeman and Klug Corporation. The new machine shop manufactured and repaired metalworking and machine tools. Before long, the growing company needed to expand, and additions were made to the building in 1976 and 1983. Herdeman Corporation remains in business today, under the leadership of Henry's son Eugene.

Jesse and Josephine Samano opened Samano's Hacienda restaurant in a small building on Squire Avenue in 1967. Three years later, they moved to a historic tavern/rooming house built in 1901 by the Miller Brewing Company. When the interior was completely remodeled in 2001, this replica of the original bar was reconstructed from old photographs. Today, the fourth generation of the Samano family serves dishes made using the original recipes.

Owner Lyle Combs is shown in his store, Collage Furniture, located on Packard Avenue. Combs had worked at Ladish, Dretzka Furniture, and Porter's of Racine before starting his own business in 1969. He had a store both in Cudahy and in South Milwaukee, but closed the South Milwaukee store after a fire in 1973. Combs kept the Cudahy store open until 1989 and spent many days decorating homes throughout the area.

Six
Time for Redevelopment and Revitalization

Arby's Restaurant opened in Cudahy in 1970, with the company's iconic neon cowboy hat sign lighting up Packard Avenue. The building was remodeled twice—once in 1975 (pictured) and again in 1981—in order to keep up with changes in the corporate brand image. The hat sign, however, remained in place and today is one of only two in existence in Wisconsin.

Pioneer Commercial Cleaning Inc. was established in 1971 by William Macknight and George "Al" Gaidosh. Having started the business on a part-time basis, it has now expanded to one of the largest privately owned janitorial companies in Milwaukee. The company was originally located on Plankinton Avenue but moved into the former Venus Ford building on Packard Avenue in 1998. The company fleet and supplies are housed in the former garage space.

Ron Ploeger and Damian Dominski opened Airport Glass and Plastic Ltd. on March 17, 1975. As the business grew, Dominski bought out his partner and moved into the former Huebner Dairy on Layton Avenue in 1979. The business specializes in flat glass and plastic products such as storefronts and doors, plate windows, tabletops, beveled glass, and mirrors. Longtime employee Bob Mirsberger (left) is pictured with owner Damian Dominski.

Ron and Judy Miller opened the Rollaero roller-skating rink in April 1979. A champion skater, Judy taught at several area rinks. Ron worked in construction and salvaged many of the building materials, including the arched roof beams from the former Pallomar Roller Rink. Family members and friends helped build and later worked at the rink. The roller rink has been an entertainment destination in Cudahy for over 35 years.

Salvatore Purpora opened Godfather's Pizza of Milwaukee in 1977 while still a college student. In 1982, he purchased Papa Luigi's Pizza on Layton Avenue in Cudahy. The small pizza parlor quickly developed a big following. Purpora expanded the restaurant in 2002 and again in 2007. He opened Papa Luigi's II in South Milwaukee in 2006 and recently passed the management of Cudahy's Papa Luigi's to the second generation: his son Frank.

Lou and Judy Geiger, pictured with Pres. George W. Bush and Laura Bush, started Medivan Inc. in December 1985. The company provides two specially equipped vans that travel to work sites to test employees for noise-related issues, respiratory clearance, and any other OSHA-required monitoring. In 2006, the company was one of the first in the state to establish health savings accounts for its seven employees. President Bush contacted Judy for information about Medivan's health insurance program and asked her to be his guest at a West Allis, Wisconsin, campaign stop on November 22. The couple was also invited to a holiday party at the White House on December 11, 2006. After Lou's death in 2012, his son Peter and wife Christine took over the business on Packard Avenue.

Randy and Kris Griffith started Key Magician Locksmiths Inc. in 1987 in downtown Cudahy. Besides cutting keys, they offer emergency lockout service and can re-key locks, open safes, and make laser-cut high-security keys and transponder keys. This family business also makes vinyl signs and offers engraving for its customers. Kris is pictured next to Randy's collection of antique locks.

Authentic Automotive owner Jim Plimpton (left) and employee Shawn Kelly stand by a 1969 Ford Talladega being restored. In addition to restoration, the shop also offers collision repair, high performance tuning, custom paint for motorcycles, and used cars for sale. Owners from across the United States ship their classic, antique, and vintage vehicles to Cudahy for restoration. The shop, located on Packard Avenue, opened in 1988.

Julia Gard established Gard N Angel Child Care in 1989, leasing space in the former Holy Family parochial school. Julia (left) is owner and administrator of the center and daughter-in-law Laura (right) is director. In August, 2011, Gard N Angel moved into the former Dutchland Dairy building on Packard Avenue. The new building offers classrooms for infants through 12-year-olds, who are cared for by a dozen teachers.

Established in 1990, Superior Health Linens offers laundry service to health care facilities, delivering hygienically cleaned laundry to an area of over 29,000 square miles in Wisconsin and Illinois. After the company ownership changed in 2007, business tripled from 24 million pounds processed annually to 72 million pounds, and three new plants were added. Superior Health Linens is accredited by the Healthcare Laundry Accreditation Council, one of only 75 such laundries nationwide.

Christina Mosur (left) and Angie Behnke assist customers in the selection of designer frames at VisionHealth EyeCare Center. Dr. Richard Miller established the practice in 1993 in Packard Plaza. In 2006, he completed an extensive renovation on a building on Packard Avenue in downtown Cudahy, and in 2012, the City of Cudahy awarded the practice a Commercial Vitality Award.

Jeff Burckhard started Jeff's Automotive in Milwaukee in 1992, having worked as a mechanic since 1975. In 1995, he moved to Nicholson Avenue in Cudahy, taking over the former site of Pavelich Motors. Burckhard sold the business in 2003, but found that he missed it. When the opportunity arose to buy back the shop in 2007, he took it. Jeff's Automotive maintains a clean shop and has a great reputation.

Dr. David Nyland established the Nyland Chiropractic Clinic in 1996. A graduate of Palmer College of Chiropractic, Dr. Nyland opened his first office on Packard Avenue near Plankinton Avenue before moving to his present location in 2012. Dr. Nyland has been a member of the 128th Air Refueling Wing of the Wisconsin Air National Guard for over 28 years and is also active with Shriners International.

Founded in 1997, National Tissue Company moved into the former Bostrom seating manufacturing plant on Layton Avenue in 2000. National Tissue converts recycled paper into disposable products such as napkins, hand towels, and bathroom tissue. Mike and Julie Graverson ran the company from 2003 until it was purchased by NPS Corporation in 2014. Employee John Bond is pictured next to a machine that rolls and cuts bathroom tissue.

In 1997, Ernest "Ernie" Wunsch opened Skyline Catering in Bay View. He moved to Cudahy in 1999, occupying his current space with retail outlet on Pennsylvania Avenue in 2009. Ernie and his 28 employees offer catering services to 250 clients throughout southeastern Wisconsin. The business was recognized as the Cudahy Chamber of Commerce business of the year and received the first 128th Air Refueling Wing recognition award ever given.

Choice Landscaping was established in 2001 by William Hess. Nine years later, he opened a garden center retail outlet on Whitnall Avenue in Cudahy that showcases beautiful plants, garden accents, and supplies for purchase. The business offers complete landscaping design, installation, and maintenance services as well as equipment rental and seasonal services like snow removal.

Husband and wife entrepreneurs Lee Barczak and Jane Schilz purchased the former Sheridan Hotel and Fountain Blue restaurant in 2004, after it had been vacant for six years. The couple completely renovated the property, resurrecting the storied hotel and restaurant in 2007. Sheridan's is an American bistro offering nouveau-style cuisine along with an extensive wine list, coffee bar, and tempting desserts. The restaurant offers both indoor and outdoor seating with vistas of nearby Sheridan Park and Lake Michigan. Sheridan House is a stylish boutique hotel featuring 12 guest rooms with decor inspired by famous wine-making regions of the world. Hotel guests are pampered, with an emphasis on quality furnishings and luxurious private retreats.

From left to right, employees Amber Vavrusa, Rick Jenkins, Tyler Victory, and Steve Whitford stand among the many bicycles and accessories for sale at South Shore Cyclery. The shop offers bicycle repair and restoration services. Co-owners Steve Whitford and Scott Wilke also showcase their extensive antique bicycle collection in a free museum in the store. South Shore Cyclery brought international bicycle racing to Cudahy in 2010, 2011, and 2012 when it sponsored SuperWeek races.

Joe Halser opened City Lounge in 2007 as one of the few smoke-free bars in the Milwaukee area. Originally built in 1925 as the Esgandarian Hotel, the building was home to a number of taverns through the years before a major fire gutted it in the 1980s. Halser refurbished the space, furnishing it with historic Milwaukee artifacts, and opened the bar. In 2014, he sold the business to Alex Ahmad.

Kohl's grocery store was built in 1960 on the site of the former Sadlow hotel, which was razed in May 1960. The store was in operation until 1999, after which the building remained unoccupied for over 15 years. During this time, the roof leaked, causing substantial damage to the interior of the building. Several feet of standing water flooded the basement, asbestos tiles were found throughout the building, and a serious mold problem developed, hampering efforts to redevelop the building. In December 2010, Todd and Kathy Rasmussen, owners of Affordable Heating and Air Conditioning, purchased the property. The couple completely remodeled the building and moved their business into the newly renovated facility in December 2011.

Todd Rasmussen and Roger Sliven started Affordable Heating and Air Conditioning in 1986, operating their business out of a garage for the first six months. In January of the following year, they were able to purchase a former electrical substation. By 2010, the business had outgrown that building, and Rasmussen purchased a former Kohl's grocery store across the street, completely remodeling it. The new state-of-the-art facility features an extensive parts warehouse as well as a custom fabrication shop. Todd and wife Kathy, together with a workforce of 11 employees, install, repair, and update customer HVAC systems. The company received the Business Vitality Award from the Cudahy Chamber of Commerce in 2012 as well as recognition from the City of Cudahy, Milwaukee County, and the State of Wisconsin in gratitude for their transformation of the abandoned building.

Sal Purpora established S & P Equipment in 1981 and moved to Cudahy in 2010, occupying the former Worldsbest Industries plant. The business is Wisconsin's largest new and used dealer of restaurant and grocery equipment. On-site technicians repair and recondition used equipment, offering a 30-day warranty. Customers can come directly to the 90,000-square-foot warehouse or purchase merchandise online and have it shipped.

Judy Carlin opened the Gift Shoppe in 2010, offering a variety of gifts, home decor, and jewelry. The shop is best known for its wind spinners, showcased in a colorful wind garden and in yards throughout Cudahy. In 2011, Carlin was named Business Person of the Year by the Cudahy Chamber of Commerce, and in 2014 and 2015, the shop was voted "Best of Milwaukee" by readers of the *Shepherd Express*.

Disc Go Round moved to Cudahy from Greenfield in March 2011. Owner Kevin Sinjakovic buys, sells, and trades music, video games, movies, and collectibles in the former Packard Avenue Garage building, erected in 1927. Prior to Disc Go Round, the building housed an office for the Wisconsin Natural Gas Company in the 1950s and 1960s and primarily retail storefronts in later years.

Alicia "Lala" Guerra opened Lala's Place in Cudahy in March 2012, offering authentic Mexican fare and a friendly atmosphere. Guerra came to Milwaukee in 1987 from Guanajuato, Mexico, and found work at Conejito's Place on Milwaukee's south side, where she was a fixture for 25 years. Her son Pepe Santa Cruz is co-owner and cook. Built in 1901, the building was home to the Cudahy Restaurant for over 75 years.

In 2009, Jenny and James Marino purchased Cybros Inc., an established Waukesha bakery selling health foods, including sprouted grain products. In February 2013, the couple rebranded, becoming Angelic Bakehouse. In just four years, they increased the business fivefold and outgrew their 7,000-square-foot facility. On May 20, 2013, the duo broke ground on a new, 22,000-square-foot building in Cudahy that would enable the company to continue to grow as a national distributor. They moved in December 2013, and opened a small retail outlet in the plant the following year. Angelic Bakehouse offers a variety of products, including breads, rolls, wraps, and pizza crusts. All of their foods are made with sprouted grains and contain only non-GMO ingredients and no artificial sweeteners, fats, or preservatives.

Covenant Healthcare purchased the Fine-Lando Clinic on Ramsey Avenue in 1996, and 10 years later, the company changed the name to the Wheaton Franciscan Medical Group Fine-Lando Clinic. In 2014, the clinic was replaced with a 10,000-square-foot facility on an adjacent land parcel and renamed Wheaton Franciscan Medical Group–Cudahy. The state-of-the-art medical office features primary care physicians as well as specialists and has partnered in many community health programs.

After many years of selling her confections at local farmers' markets, festivals, craft shows, and coffee shops, Jennifer Clark opened Jen's Sweet Treats on Packard Avenue in Cudahy in November 2014. Jennifer and daughter Cortney, pictured in the shop, offer a delectable assortment of cupcakes, cookies, muffins, brownies, turnovers, and cake pops. Custom orders and daily lunch specials are also available.

Cudahy's Supermarket owner Zaal M. Zaal (left) is pictured with his mother inside the store. He opened the supermarket on January 19, 2015. The building was originally home to the Majestic Theatre, operated by Jacob Disch from 1912 to 1927. In the years following, various grocery stores, meat markets, bakeries, and a liquor store occupied the space until Nick Demos opened his photography studio in 1979.

CLE Haven Cudahy assisted-living center opened on the corner of Barnard Avenue and Sweet Applewood Lane in the fall of 2015. Operated by Creative Living Environments, the facility offers 24 units, and a second phase of construction will include an additional 24 units. The facility provides support for seniors with mobility, medical, or memory care needs under the guidance of director Laurie Hintz.

Discover Thousands of Local History Books Featuring Millions of Vintage Images

Arcadia Publishing, the leading local history publisher in the United States, is committed to making history accessible and meaningful through publishing books that celebrate and preserve the heritage of America's people and places.

Find more books like this at
www.arcadiapublishing.com

Search for your hometown history, your old stomping grounds, and even your favorite sports team.

Consistent with our mission to preserve history on a local level, this book was printed in South Carolina on American-made paper and manufactured entirely in the United States. Products carrying the accredited Forest Stewardship Council (FSC) label are printed on 100 percent FSC-certified paper.

MADE IN THE USA